IMAGES of America
BRIDGES OF SPOKANE

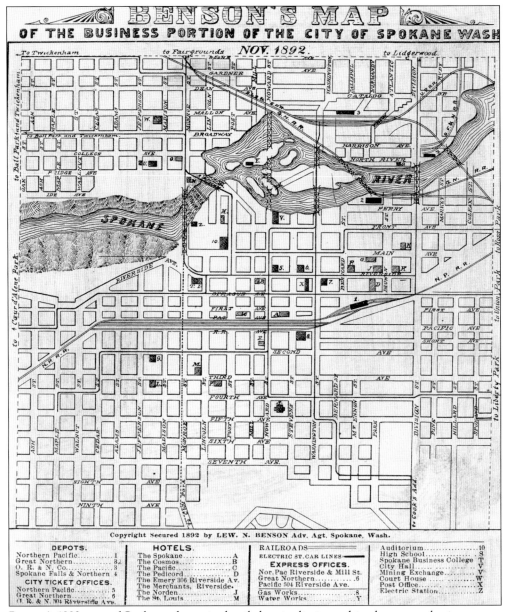

Benson's 1892 map of Spokane shows in detail the city limits and its downtown business core. By the early 1890s, steel bridges dominated, replacing the dilapidated wooden structures from the early 1880s. The map shows the Monroe Street Bridge (left center), Howard Street (center), Washington Street (right), and the Division Street Bridge (far right). (Courtesy of Washington State Archives, Spokane Historical Preservation Photographic Collection.)

ON THE COVER: With the completion of the Monroe Street Bridge, a north-south thoroughfare within the city had finally been established. The stage was now set to link the city with the western hinterland and beyond to parts west of the Cascade Range. Construction of the Hangman Creek High Bridge, also known as Sunset Boulevard, began in 1911. (Courtesy of Washington State Archives, Eastern Region, Spokane City Public Works Collection.)

IMAGES
of America

BRIDGES OF SPOKANE

Jeff Creighton

ARCADIA
PUBLISHING

Copyright © 2013 by Jeff Creighton
ISBN 978-0-7385-9635-8

Published by Arcadia Publishing
Charleston, South Carolina

Printed in the United States of America

Library of Congress Control Number: 2013933747

For all general information, please contact Arcadia Publishing:
Telephone 843-853-2070
Fax 843-853-0044
E-mail sales@arcadiapublishing.com
For customer service and orders:
Toll-Free 1-888-313-2665

Visit us on the Internet at www.arcadiapublishing.com

*To all those bridge engineers who served the
City of Spokane during its most formative years*

Contents

Acknowledgments		6
Introduction		7
1.	The Washington Street, Howard Street, and Post Street Bridges	11
2.	The East Olive Avenue and Mission Avenue Bridges	31
3.	The Monroe Street and Division Street Bridges	57
4.	The Hangman Creek, Chestnut Street, and Eleventh Avenue Bridges	85
5.	The Downriver Bridge and the Union Pacific Trestle	101
6.	Expo '74 and Reconfiguration	117
Bibliography		127

ACKNOWLEDGMENTS

Thanks to Lee Pierce, the archivist for the Washington State Archives, Eastern Region, Cheney, Washington, for the high-quality images from the Public Works Photographic Collection contained within these pages. This is truly a priceless collection of early construction-progress photographs documenting some of the city's most historic bridges.

Also to Reva Dean, the curator of the Northwest Room, Spokane Public Library, Downtown Branch. Reva was kind enough to let me scan anything and everything I could get my hands on. The Northwest Room contains some of the earliest bridge photographs on record. In addition, the assistance of James Moe, the bridge inspector for the City of Spokane, was invaluable. Jim shared a variety of historic documentation on the early bridges.

I would also like to express my appreciation to my editor, Amy Kline.

Unless otherwise noted, all photographs are courtesy of the Washington State Archives, Eastern Region, Spokane City Public Works Photographic Collection.

INTRODUCTION

Spokane is one of the best examples in the state of Washington of a city built around a river. Located in extreme eastern Washington, Spokane has an illustrious history, spanning from the time of the early northwestern fur trade to the arrival of the Northern Pacific Railroad in 1883. Spokane was a thriving community from 1900 to 1915, one of the city's major periods of growth. Railroads, the expansion of the central business district, and the rise of extractive industries such as mining and logging assured the region of lucrative trade, even outstripping the vaunted hub community of Walla Walla.

Though much has been written about Spokane and the "Inland Empire" concerning the endeavors cited above, nothing has approached the one aspect of transportation that eventually brought the city of Spokane together with respect to its political, social, and economic cohesion. The idea of bridges as a unifying force goes beyond mere metaphor with regard to Spokane. The Spokane River, which bisects the city, represented a barrier much like a mountain or a canyon, barriers that could only be surmounted for very good reasons, usually those of monetary importance. The early bridges of Spokane were located on the periphery of the city's central business district. These early structures were primarily thoroughfares connecting the Walla Walla area to the Colville Valley region north of Spokane. In effect, the bridges facilitated the transfer of people and material goods to the various mining districts; thus, the earliest Spokane-area bridges did not really benefit the core of the fledgling city.

From the early 1880s through the first decade of the 20th century, dozens of bridges had been erected across the Spokane River and its tributaries throughout the county. These early bridges undoubtedly served a great purpose in the development of the region north of the Spokane River. Obviously, many of these bridges were not built to the standard long held by the engineering experts who were designing and constructing bridges on the East Coast and in Europe. Be that as is it may, these early structures ushered in an era of bridge building unprecedented in the history of the inland Northwest.

Between 1889 and 1896, a total of six bridges were built, only to be washed away by floodwaters, some within months of their completion. The lack of money, material, and construction techniques added up to continuous problems with sound construction practices. Serious bridge building in Spokane and the vicinity went through a trial-and-error period, which, by the early 1900s, yielded a standard of construction on par with most major cities in the country. This watershed period began in 1907. After numerous problems with washouts and structural failures, the citizens of Spokane demanded solid, well constructed bridges. Initially, steel replaced wood, and later, concrete dominated all bridge building within the city.

Historian David H. Stratton has stated, "From the late 1890s to about 1912, a great flurry of construction created a modern urban profile of office buildings, banks, department stores, hotels and other commercial institutions," stretching from the Spokane River south to the original site of the Northern Pacific tracks below the South Hill. By 1910, the city boasted a population of roughly 104,000.

One event that stirred the interests of bridge builders and the Spokane citizenry alike was the so-called Bridge Smoker. Amongst the haze of cigar smoke, the Bridge Smoker, held on the evening of December 11, 1907, kicked off several years of political wrangling that would see the ousting of more than a few city engineers and public works officials, the destruction of political careers, and a near standstill of city government in general. With the use of lantern slides and numerous scientific reports, evidence was being presented solidifying the need to construct concrete bridges in Spokane. These findings were based on both the structural and aesthetic climate of bridge construction at the time. Much of the discussion that night also focused on the issue of steel versus concrete.

The first speaker of the evening was city engineer Charles McIntyre, who was often at odds with supervising engineer S.H. Knight. McIntyre began his address with a history of Spokane bridges from the earliest times to the present. He further outlined the need for better bridges within the city's core business district, stating that the current structures are "of antiquated, flimsy and freakish design," that have been "thrown together . . . not only defacing the beauty of the river, but menacing the lives of the thousands who have to cross them each day." McIntyre cited the Howard Street, Washington Street, Division Street, and East Olive Avenue Bridges as especially dangerous, primarily due to grade crossings. McIntyre's five-year outlook included the construction of no less than 10 bridges and viaducts costing in excess of $1,218,952. A total of $507,666 of the cost would be borne by the city and by bond issues.

No less an advocate for the improvement of Spokane's bridges, S.H. Knight, the supervising engineer of Chicago, and at the time heading up the construction of the Washington Street Bridge, was wary of concrete as a cure-all for Spokane's bridge problems. Knight, displaying an air of conservative construction philosophy, admitted that while concrete had its place, it surely was not the answer for all structures. He went on to state, "The use of reinforced concrete . . . has been little short of marvelous and it is the present-day engineering fad. Like most fads, it derives its popularity through an excess of zeal in the exploitation of one or more worthy objects, which all fads possess." In other words, Knight was of the opinion that concrete was appropriate in certain instances, but where steel would suffice, then—primarily for cost purposes—steel should be used. He added, "We have learned how to make concrete strong . . . let us learn how to make it beautiful."

Indeed, there is something to be said about a concrete monolith without character or aesthetic attributes. Addressing these concerns was J.C. Ralston, the well-traveled engineer extraordinaire. Presenting a paper titled "The Esthetic in Bridge Design," Ralston advocated the melding of engineering and architecture in order to "accomplish the happiest and most artistic results in bridge building."

Often credited for lifting the city engineer's office out from "under the atrophying influences of indurated city politics," Ralston, who was named chief engineer in January 1908, had a keen sense of what Spokane's future held in the way of bridge building. Using illustrations of bridges from across the country and abroad, Ralston emphasized both serviceability and beauty with regard to concrete and steel bridgework.

Thus was the vision of J.C. Ralston, a vision that would soon be shared by many Spokanites in the next few years. This trend was evident, as numerous illustrated articles began to appear in the *Spokesman-Review*, often featuring bridges constructed in Germany and Italy that typified the ornate style Ralston had alluded to. Even bridges constructed in the South and on the East Coast, including the Cumberland River Bridge in Nashville and a large concrete structure rumored to have been the largest masonry span in the world, over the Rocky River on the western edge of Cleveland, were featured in an effort to promote similar structures in Spokane.

With the recent sale of $400,000 worth of bridge-improvement bonds, Spokane was poised to dive headfirst into an unprecedented era of bridge building. This so-called "bridge frenzy" had begun in late 1907, and continued over the next 10 years. Interestingly, 1908 was the year of the greatest activity. Almost daily, the subject of bridges appeared in the *Spokesman-Review*, chronicling the bridge-building process in a soap-opera-like fashion.

It is this story that is presented in the following chapters. Through photographs, Spokane's infrastructure is recorded in great detail. From the Washington Street Bridge in 1907 to the completion of the Downriver Bridge in 1928, the city would soon earn the mantle "the City of Bridges."

With the coming of Expo '74, the first world's fair to be held in a city as small as Spokane, major changes were in the works. Spokane's centerpiece of railroad yards and elevated track within the downtown core was razed to accommodate the fair. The Howard Street Bridge by then had been reduced to a pedestrian span, while the Washington Street Bridge over the south channel was extensively reconfigured. Havermale and Canada Islands also underwent makeovers—Washington Street's roadway across Havermale Island was now covered over, creating a tunnel for a building site above. While the 1974 world's fair brought dramatic change to the city, its bridges, with the exception of the south channel span of Washington Street, remained intact.

Since 1974, several downtown bridges have been replaced, including the Washington Street Bridge's north channel in 1983, the Division Street Bridge in 1994, and the Monroe Street Bridge in 2003. Although the Monroe Street Bridge looks identical to the original span of 1911, it has been almost completely restored with 21st-century technology. While the Howard Street Bridge is still intact, it is only open to foot traffic. The only original concrete-arch bridge within the city core open to vehicular traffic is the 1915 Post Street Bridge, which has recently been slated for replacement. One other exception to this is the Hangman Creek Bridge, which is located outside of the city's core.

Today, the classic multi-span concrete-arch bridge is basically a thing of the past. Newer spans are usually generic-looking concrete-box girder affairs with little aesthetic appeal. Still, the few concrete-arch bridges left in Spokane serve as a reminder of the heyday of bridge building, long since past.

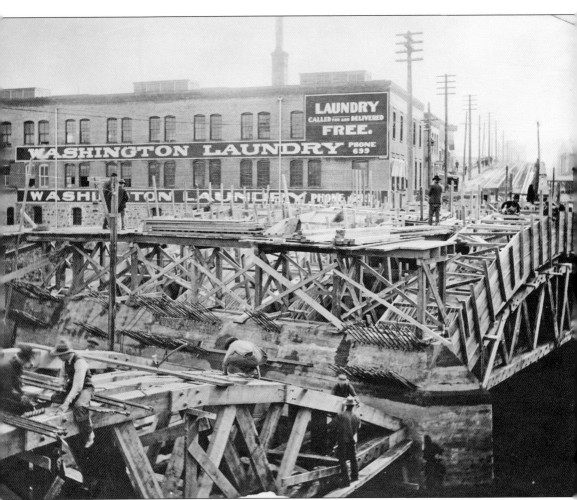

The Washington Street Bridge, built in 1907–1908, was one the first concrete-arch bridges built in the state. Once completed, it was the catalyst for at least eight more Spokane bridges. Designed by engineer J.B. Strauss, the project had it problems from the outset. Accusations of fiscal irresponsibility as well as a general animosity between the project and the head engineer became so scandalous that it is a wonder the bridge ever got built at all. This photograph looks north, with the streetcar tracks running up Washington Street. Crews are working to complete the falsework for the pouring of concrete. The bridge is being constructed over the north channel, where it remained until it was replaced in 1983. Before being demolished, the north-channel span of the Washington Street Bridge was placed in the National Register of Historic Places. (Courtesy of the National Register of Historical Places.)

One

THE WASHINGTON STREET, HOWARD STREET, AND POST STREET BRIDGES

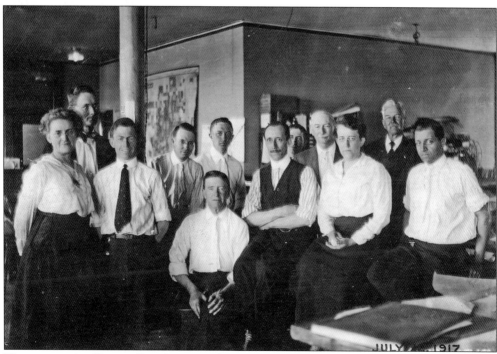

The engineer's office staff in this 1917 photograph represented the core of the city engineer's office. A few of these individuals probably took part in the heyday of bridge building, beginning with the construction of the Washington Street Bridge over the north channel of the Spokane River in 1907.

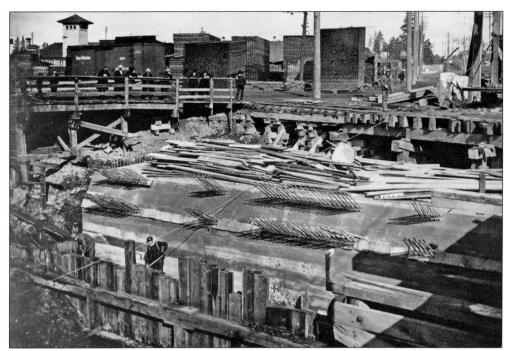

Construction of the Washington Street Bridge began amidst political infighting between engineers and the city council. Chief engineer Charles McIntyre and project engineer S.H. Knight were at odds concerning the overall progress of the construction. McIntyre was highly critical of the waste of time and money by Knight. Both men were summarily fired toward the end of the project.

This photograph shows the placement of newly poured concrete for the abutment and foundation. The rebar in the face of the abutment would eventually form the base for the concrete-arch segment of the bridge. Note the streetcar moving south into the downtown core. Once the bridge was completed, streetcars took more of a straight trajectory to cross the river, instead of the sharp curve of the older span.

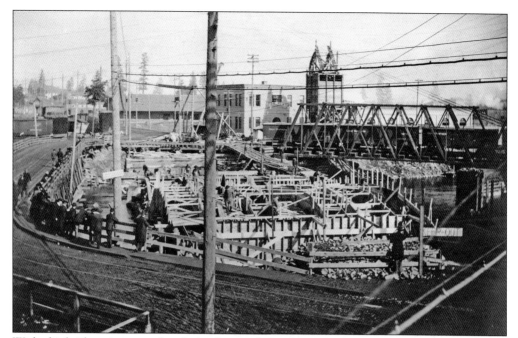

With the bridge piers completed, the formwork for the arch segments continued. The earlier Washington Street span is seen on the left, while the Great Northern Railroad steel-truss deck is on the right. Onlookers are gathered along the railing; the construction of Spokane's first concrete-arch bridge created great excitement throughout the city.

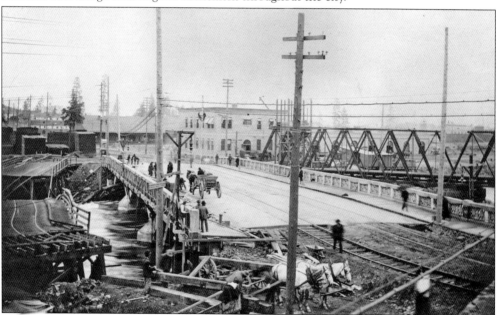

Completed in 1908, the Washington Street Bridge consisted of a 242-foot, three-span, flattened, ribbed, steel-reinforced concrete-arch structure. Each of the spans measured 77 feet in length, with a rise of a little more than nine feet in height. The design is credited to J.B. Strauss of the Chicago-based Strauss Bascule and Concrete Bridge Company. On the left, the old bridge is in the process of being dismantled.

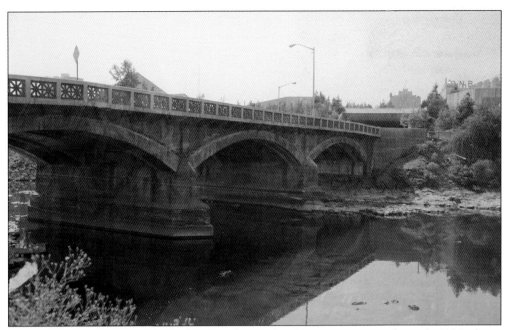

The Washington Street Bridge looking south into the downtown core in the early 1980s shows little wear when compared to the photograph below, taken shortly after the bridge's completion in 1908. The tunnel (upper right) crosses Havermale Island and into the central core. The tunnel was constructed prior to Expo '74. (Courtesy of the Library of Congress.)

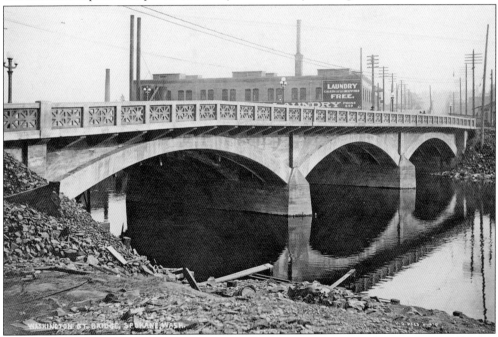

The completed Washington Street Bridge cost the city a little more than $264,000. The only plan revision had to do with the design of the deck system in order to accommodate the tracks for the Inland Railroad system. Once these problems were resolved, the bridge featured a 44-foot-wide roadway curb to curb, two sidewalks, and two railway tracks.

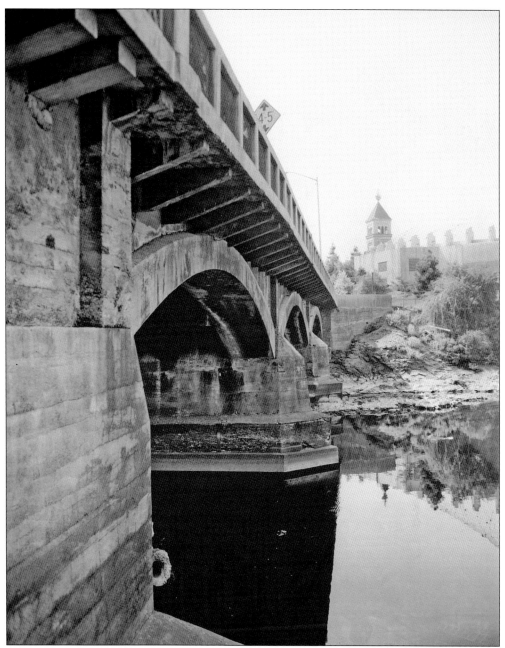

This close view of the Washington Street Bridge shows the low-profile design of the three flattened, ribbed arches as well as the massive concrete piers supporting them, spanning the north channel of the Spokane River. Not only was the Washington Street Bridge one of the first of its kind to be built in the state, it also set the tone for all future bridge construction in the city. Concrete-arch bridge construction represented a sense of permanence, and all new bridges built within the city soon followed suit. The Washington Street Bridge was replaced in 1983, but not before being placed in the National Register of Historic Places in 1982. (Courtesy of the Library of Congress.)

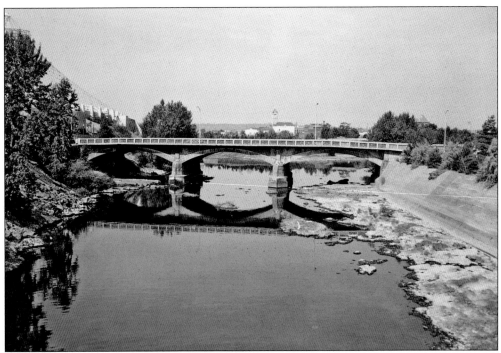

By the late 1970s, the Washington Street Bridge showed little deterioration for a bridge that had been in service for more than 70 years. Its low-profile design enabled the use of closed spandrels as opposed to opened ones. Open spandrels were commonly used to allow water to flow freely through the bridge's superstructure during high-water periods. (Courtesy of the Library of Congress.)

This view from the north approach looking south into the downtown core was taken sometime in the late 1970s. The former Expo '74 pavilion (right) was retained and is now a focal point within Riverfront Park, a park created from the remnants of the 1974 world's fair. (Courtesy of the Library of Congress.)

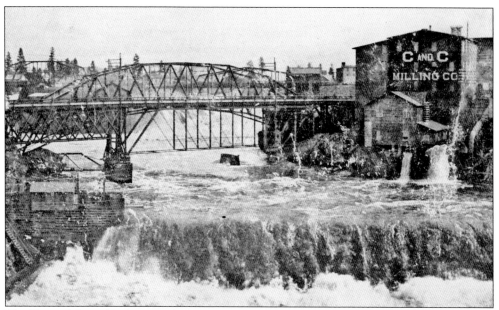

The Howard Street Bridge, seen here in 1888, was one of the earliest steel bridges in the city. It consisted of three spans, one spanning the south channel of the river to Havermale Island, one from there to Canada Island, and a third to the north shore. Three wooden structures had existed before this bridge was built. (Courtesy of Spokane Public Library, Northwest Room.)

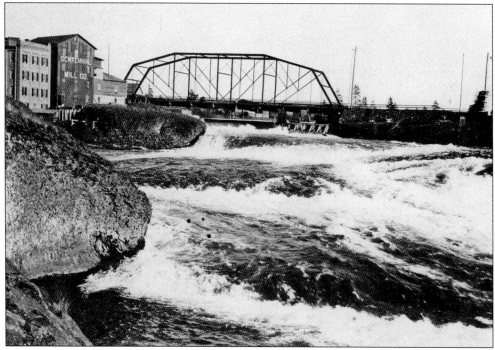

This view of the Howard Street Bridge looks upriver to the east. The King Iron Bridge and Manufacturing Company of Des Moines manufactured the iron-truss structure. Documents list a span length of 231 feet, a height of 34 feet, and a roadway width of 18 feet. This is the center span, which was eventually replaced in 1916. (Courtesy of Spokane Public Library, Northwest Room.)

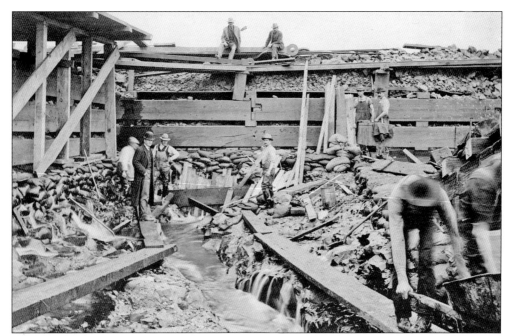

Construction began on a new concrete bridge for Howard Street in 1908. This photograph documents early excavation work for the bridge foundation. Howard Street had the distinction of being the central-most thoroughfare from the downtown business core to the north side of the river. The older steel bridge, which had been deemed unsafe, became one of several bridges to be replaced in record time.

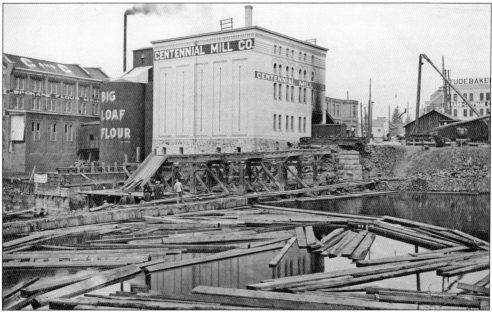

Preparations for the construction of the Howard Street Bridge over the north channel was underway in early November 1908. Flour mills such as Centennial Mill, Big Loaf, and the C and C Mill dotted the north channel in those early years, as waterpower became a necessity for these types of operations. The worker platform (center) helped to transfer material to the lower worksite.

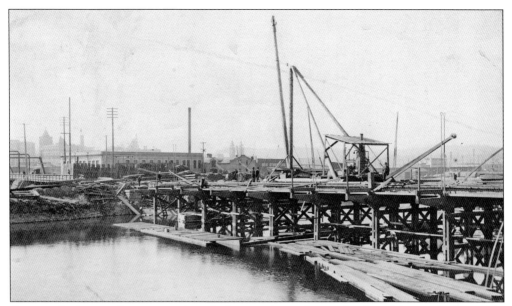

A steam donkey on the construction platform works on the south edge of the north channel in October 1908. The view looks to the south, with the center-steel Howard Street span on the far left and the central business core in the distance. Falsework material is floating in the water near the platform. This material was used to create the forms for the concrete work.

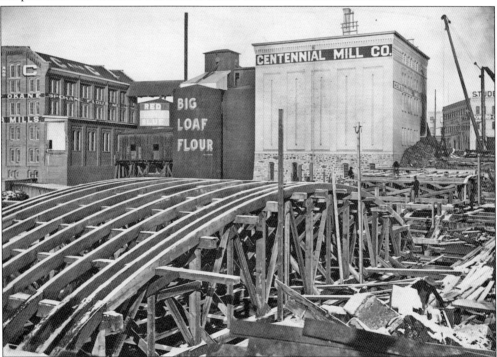

By December 1908, the massive timbering for the falsework was in place over the north channel. These forms served as the substructure for the eventual concrete pour as well as the foundation for the road deck. Careful consideration was needed to ensure proper foundation strength when constructing the concrete arch.

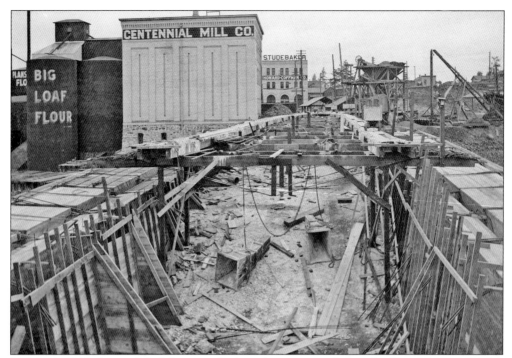

By March 1909, the road deck became the last phase in completing the Howard Street Bridge over the north channel. The timberwork seen here on the deck supported two tracks, one on each side where the deck railing will eventually be poured. The rails were used to bring in material to the site. Note the small-wheeled cart in the upper right.

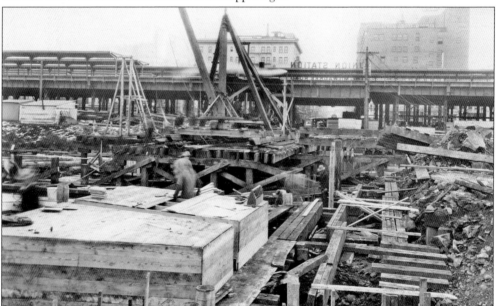

A little more than 20 years after the completion of the Howard Street Bridge, in 1930, the south channel span was replaced. Forms for the concrete piers are being constructed in the foreground in front of the workers' platform and a movable crane situated on a sled. Note the elevated railway tracks above Howard Street leading into Union Station.

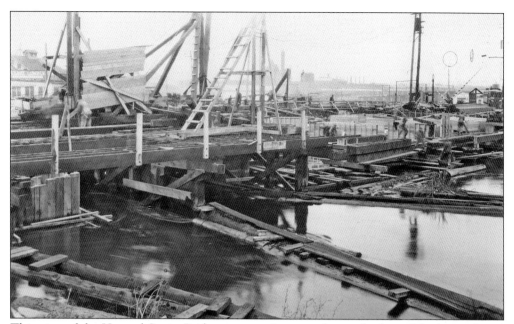

This view of the Howard Street Bridge construction over the south channel looks northwest toward the Spokane County Courthouse in the distance. Unlike other Spokane bridges, this span was not of a concrete-arch design. This photograph was taken in November 1930 and shows the progress of the foundation work.

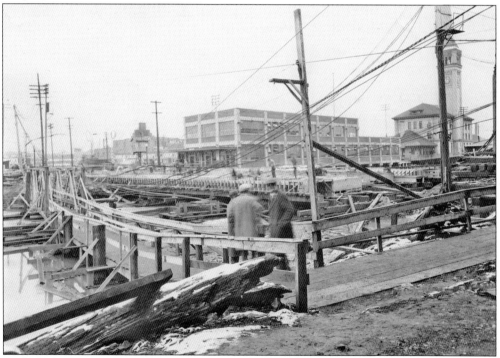

With the bridge foundation and piers in place, deck work was now in progress. This view is to the northeast, with the Great Northern Railroad station on the far right. The pedestrian walkway in the foreground was put in place during the construction period for obvious reasons.

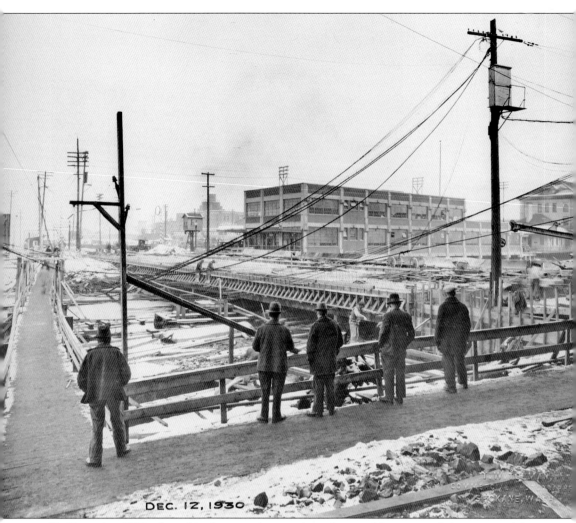

By December 1930, when this photograph was taken, the wood forms were being removed from the decking, which would then serve as the foundation for the concrete side rails. The rebar is seen for the next phase of the process to complete the railing on the bridge. This view, looking north, shows curious onlookers next to the pedestrian walkway. Once completed, the bridge was opened for pedestrian, vehicular, and streetcar use. Howard Street was one of the primary streets to connect downtown business core to Havermale Island (once simply known as the Big Island), and on to the commercial area along the north shore of the river. A far cry from the original wooden structure constructed in 1881, this bridge, completed in January 1931, is still in use today, as is the north channel bridge. The center-steel truss span was replaced in 1916 and is also still in use.

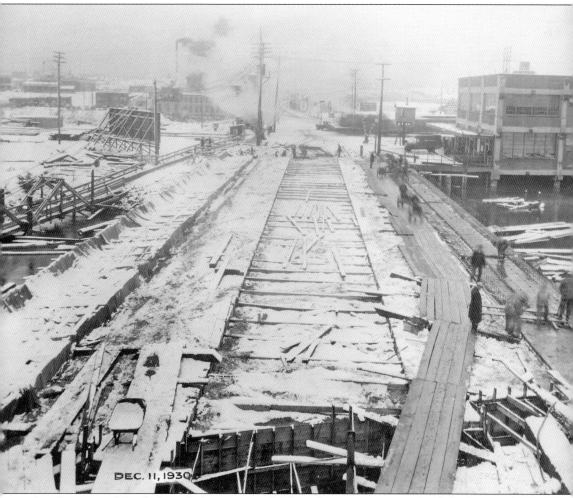

DEC. 11, 1930

Another view of the deck work shows crews wheeling the concrete carts along planks over the deck substructure to continue the pour for the sidewalks and side rails. It is apparent that the railing and sidewalk work on the west end of the bridge (far left) has been covered for protection from the cold December weather. Formwork can also be seen in the bottom center, as the south approach had not yet been completed. Crossing the bridge to the north, the center-steel truss span is in the top center, as the roadway curves slightly in a northwesterly direction and then straightens from the little island across the north channel span to the north shore. By the 1930s, the many flour mills that had dotted the north shore of the river had long since vanished, replaced by more diverse manufacturing concerns as well as small businesses.

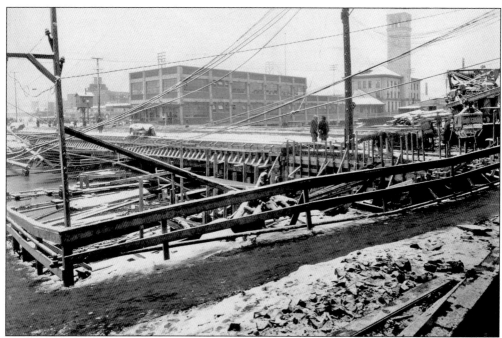

By mid-December 1930, much of the platform material had been removed as the bridge neared completion. Overhead electrical lines were in the process of being repositioned, as were the water lines that would be routed across the span under the decking to Havermale Island and on to the north side of the river. Note that the side rails have not been completed.

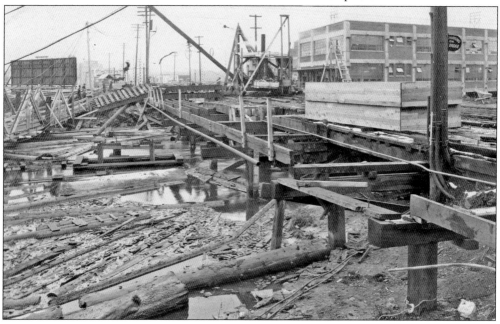

This earlier progress photograph taken in November 1930 shows the donkey operator using a crane to move debris from the work area. In just over a month, the Howard Street Bridge had nearly been completed—record time for the era. By January 1931, it was already open for vehicular and streetcar traffic.

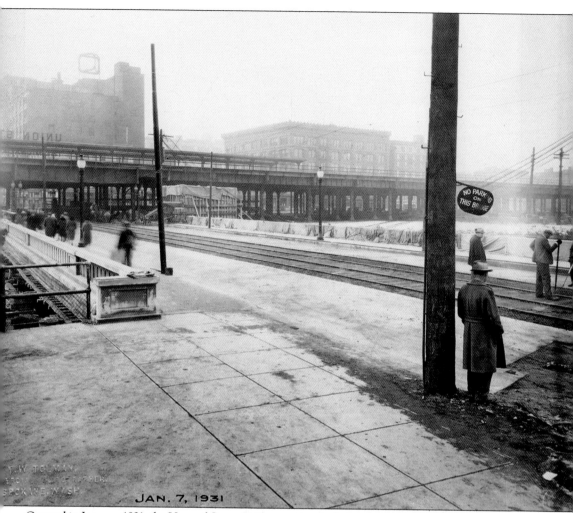

Opened in January 1931, the Howard Street Bridge consisted of a four-span concrete stringer—multi-beam structure with a total length of 165 feet. The side rails are predominately open, narrow arches with six solid concrete panels spaced at equal intervals. While the bridge opened for pedestrian traffic in early January, the finishing touches on the roadway, specifically the streetcar portion of the deck, are being completed by crews in this photograph. This view to the south shows the elevated railway tracks leading into Union Station. While Howard Street continued to be an important thoroughfare, by the early 1970s, all three spans were open to pedestrian traffic only. At present, the middle Baltimore through-truss constructed in 1916 and the south channel bridge are partially closed to pedestrian traffic due to deterioration. Still, the three bridges form an important part of Spokane's Riverfront Park, enabling recreationists to freely travel between the north and south sides of the Spokane River.

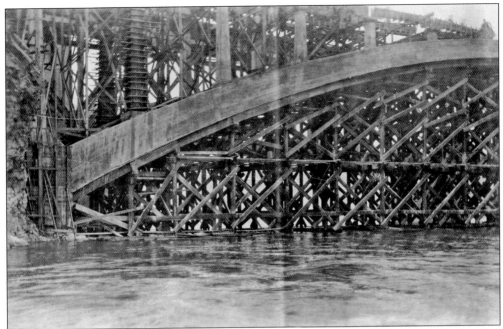

Construction was underway on the new Post Street Bridge in February 1917, replacing the older bridge erected in 1893. That bridge consisted of a single-span, three-hinged arch and two steel trusses with steel floor beams that measured 244 feet in length. This photograph shows the construction of the newer concrete-arch bridge midway through the project.

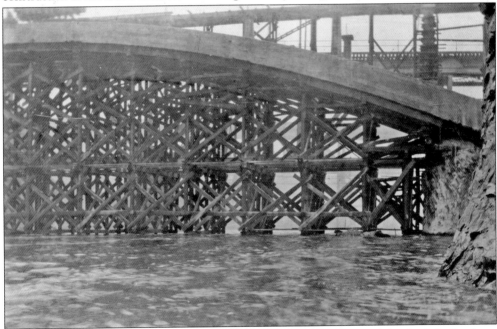

Another view of the Post Street Bridge, the arch springing from the north bank of the Spokane River, shows the massive timbering needed to support the two single-span arches under construction at the time. Unfortunately, the sleekly designed arches were not there for long. At 3:20 p.m. on February 6, 1917, the entire falsework, arches and all, dropped into the Spokane River.

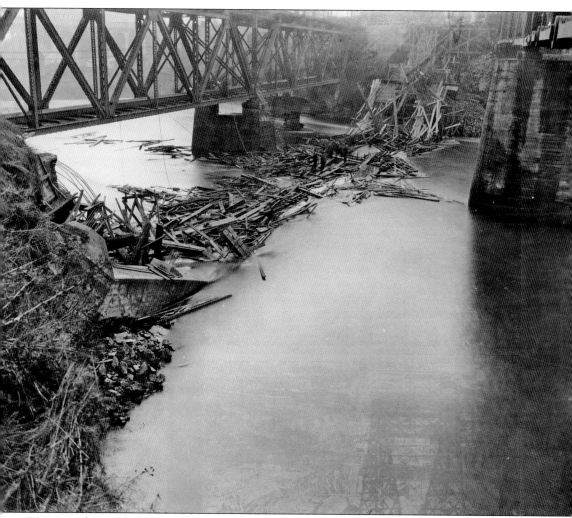

Witnesses claimed that the collapse of the Post Street Bridge sent water as high as the Washington Water Power deck truss (upper left), and that after the first big wave had gone over the falls, the back section was so great that rocks were exposed and the falls looked virtually dry for a few moments. At the time of the collapse, the bridge consisted of a 250-foot span of two-ring arches. Each ring was six feet wide and ranged in depth from five-to-six feet at center to eight feet at the abutments. It was initially thought that the location, with its solid-rock banks, was perfect for this type of design, though later investigations proved otherwise. This photograph illustrates the severity of the collapse. People are seen standing on the debris within the river, having climbed down by ladders from the Washington Water Power trestle.

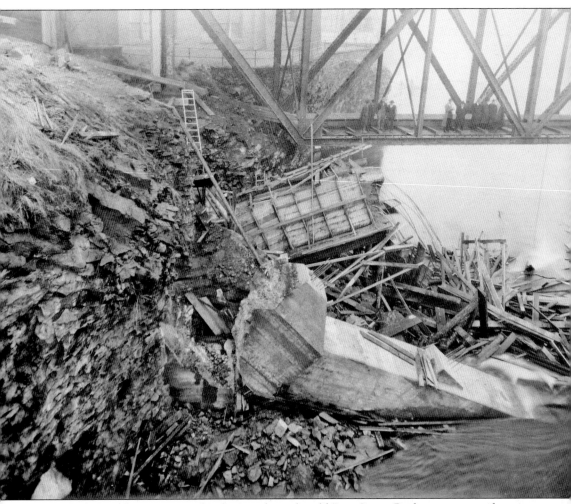

Onlookers gather to survey the damage from the old Post Street Bridge, a pretty safe vantage point and a great look at the tragedy. The demise of the bridge was an obvious setback, but the news of the 2 people killed and 10 injured was a significant blow to all. The collapse may have been due to a buckling of an improperly braced post for the falsework, or even because a carload of concrete had been dropped just prior to the collapse. Interestingly, the falsework on the bridge had been constructed under the direction of engineer Philip Kennedy, who died in a fall from the same bridge a week before and had also designed the ill-fated falsework that collapsed on the Monroe Street Bridge in 1910. Putting everything in proper perspective, this photograph shows the shear massiveness of what was lost, let alone the loss of life.

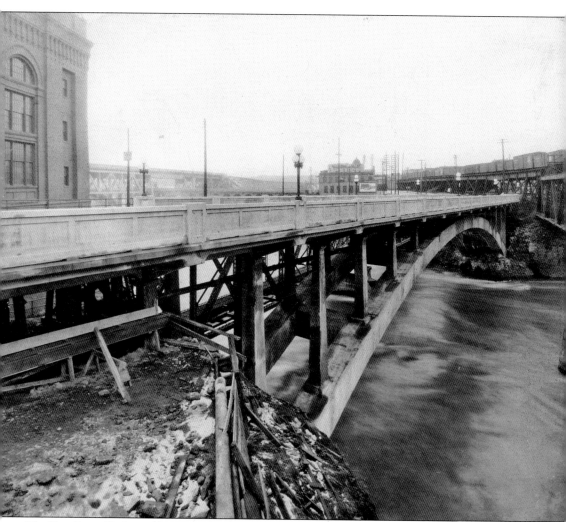

The Post Street Bridge collapse was the third such collapse within seven years, prompting some to question the expertise of those who designed such important structures. One citizen in particular, E. Tappan Tannat, who also happened to be an engineer, complained about the engineering profession in the Northwest as being prostituted by engineering politicians. Tannat accused the Spokane City Council of stifling good engineering in favor of political favoritism. Harkening back to the political free-for-all in 1908, his assessment was not far off the mark. Regardless, the Post Street Bridge was eventually reconstructed and opened for traffic in 1917. The concrete, open-spandrel, twin-single-span ring-arch bridge has an over-the-water length of 258 feet and an overall length of 330 feet. The roadway was originally 40 feet in width but was widened in 1937. Today, the bridge remains virtually the same, but deterioration has become problematic. Plans are in the works for a new bridge sometime in the near future.

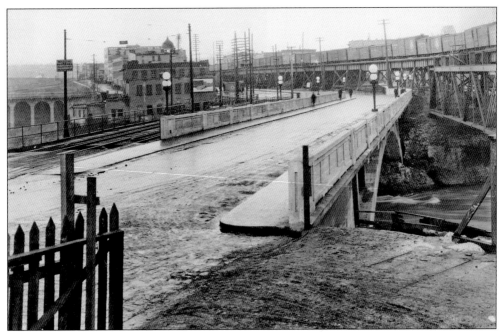

This view of the finished Post Street Bridge is to the west, with a partial glimpse of the north approach of the Monroe Street Bridge visible on the far left. The concrete arch appears to be "growing" out of the solid rock on the north shoreline. Note the tri-bulb electric lighting mounted on the solid concrete side rails.

This final view of the Post Street Bridge looks west and shows glimpses of the Spokane County Courthouse (center) and Washington Water Power's streetcar line (far left). As a premonition of things to come, a billboard in the center advertises used cars. The days of the interurban were clearly numbered.

Two

THE EAST OLIVE AVENUE AND MISSION AVENUE BRIDGES

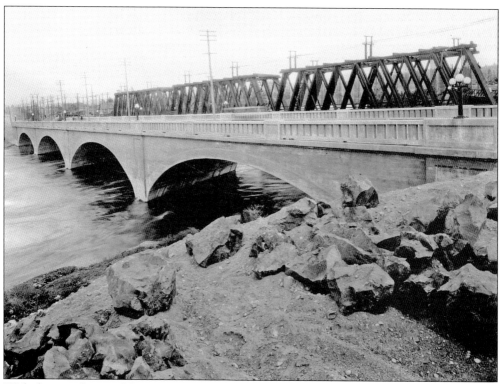

With the completion of the Washington Street and Howard Street Bridges in 1908, city engineers turned their focus to replacement structures on East Olive Avenue and Mission Avenue. Though steel bridges were proposed at these sites, east side citizens began protesting for the construction of concrete-arch bridges like their intercity counterparts had. The message did not go unheeded.

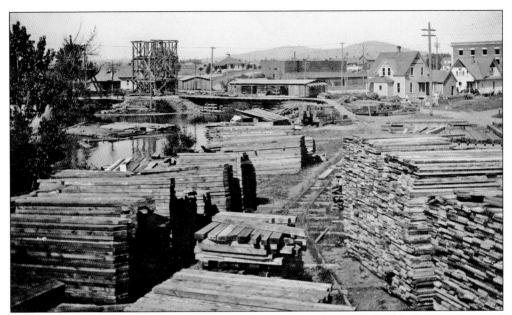

With construction of the East Olive Avenue Bridge approved in 1909, building material started to literally stack up in and around the worksite. East Olive Avenue (now East Trent Avenue) was not in the downtown city core, but east of the city and primarily in the suburbs. Originally proposed as a two-span steel bridge, the plans now called for a concrete-arch structure.

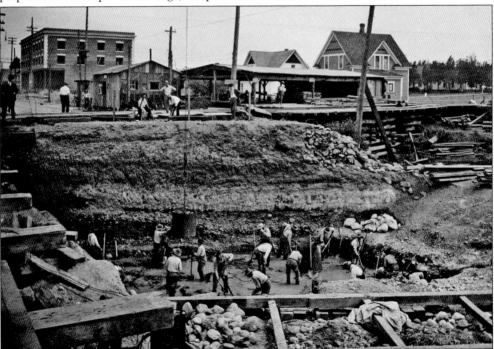

Excavation near the approach began in September 1909. These workers in the excavation area are using shovels to load excess rock into the lowered metal bucket (center) for removal. This area was eventually used for the bridge abutment as well as the foundation for the spring of the initial concrete arch.

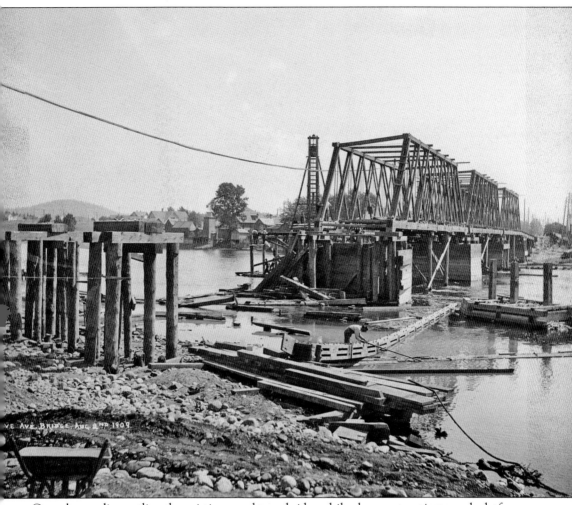

Crews began dismantling the existing wood-truss bridge while also constructing a work platform, seen partially out of view in the center. Inspected in 1903 by engineer J.C. Ralston, the report revealed in no uncertain terms that the bridge was a dilapidated flimsy mess just waiting to drop into the Spokane River. The bridge had become badly warped and at least one-to-two feet out of line. Ralston considered the bridge dangerous and not safe for street traffic. Cost estimates for the new bridge ran at just over $90,000, down from over $100,000 because of the uniformity of the river bottom. The final design consisted of a structure with five concrete arches, spanning a total length of 415 feet on nine-foot-thick piers, with an overall width of 56 feet. Elaborate ornamentation had also been planned, such as gargoyles and seated lions, but the city council thought the ornamentation too frivolous.

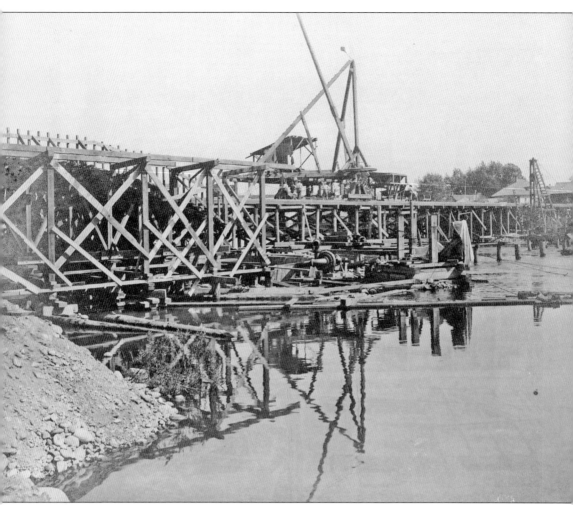

Here, construction of the falsework (far left) for the first arch has already been put in place, with the timber supports built off to the side. The donkey operator sits under a shed-roofed enclosure while controlling the vertical derrick, or crane, that has been set up to swivel at 180 degrees. The operator could easily move everything he needed to, whether it was moving timber for falsework or simply removing debris from the construction site. As the work progressed down the platform, the derrick could be moved either by a sled configuration or by a temporary track system installed upon the platform—this particular derrick moves on a track. A smaller track system for wheeled carts, in the center on the platform in front of the working crane, was typically used for bringing in concrete or whatever else might be needed. This setup was typical of most Spokane bridges, especially those constructed with a low profile.

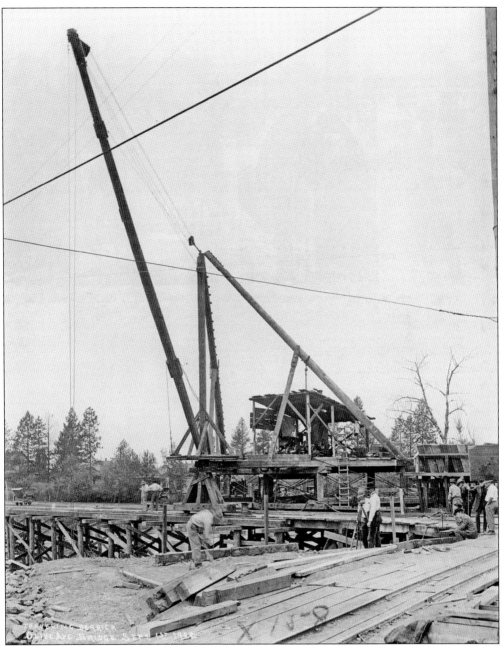

Looking from the east bank of the Spokane River, the smaller track that was used to transport material to workers' platform is in the foreground. One of the carts is on the far left, moving material down the platform line. The derrick is in the process of either lifting or lowering material to the construction area. One can only imagine the noise generated from the donkey engine concealed within the shed-roofed structure. Be that as it may, this type of construction technique endured well into the late 1920s and early 1930s in Spokane. In fact, as late as 1928, a similar donkey crane was used in the construction of the Downriver Bridge, just west of the city. In 1909, technology in some parts of the country had advanced far beyond what was being used in the growing city of Spokane. Regardless, these bridges tended to go up in record time.

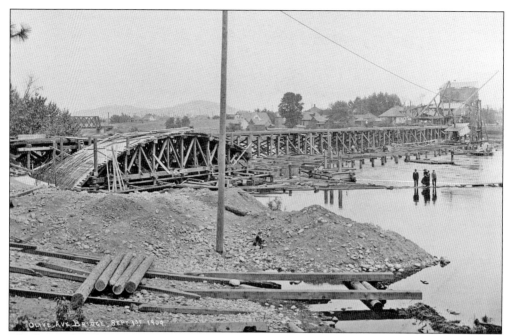
The first arch's falsework is on the far left, with rebar—for reinforcing the concrete— extending from the abutment. In this progress photograph dated September 1909, a second derrick is nearly on the river's surface, just below the derrick on the platform above. Right in front of the termination of the first arch's form are the forms for the foundation piers.

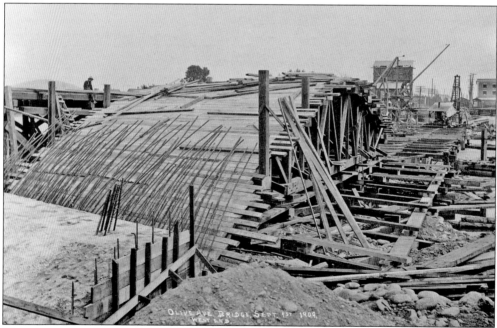
This close view of the abutment and falsework shows in vivid detail just how much hand labor goes into the construction process. The top of the falsework consists of nailed two-by-fours across the heavy timber framing, and the reinforced steel bars (rebar) are seen shooting out from the concrete abutment.

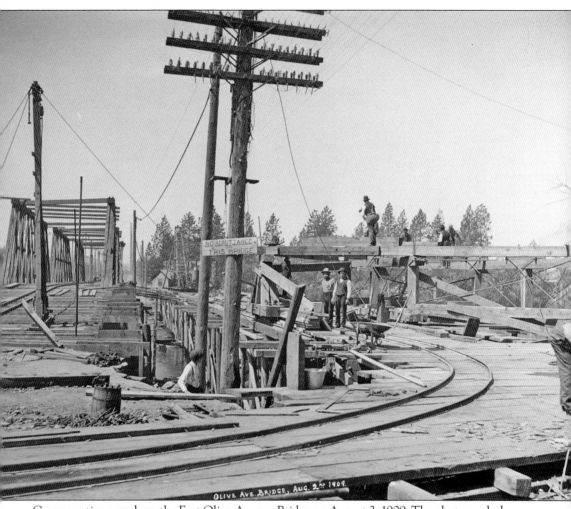

Crews continue work on the East Olive Avenue Bridge on August 2, 1909. The photograph shows the old bridge (left), the work platform for the new bridge (right), and the new bridge (out of view to the right). These workmen are local craftsmen, something that was required by a newly passed city resolution for winning contract bidders. The construction of the concrete-arch bridge necessitated the need for skilled workmen. Prior to 1909, many of the craftsmen were brought in from other areas to perform the work, but that changed for all future bridgework. Hiring local craftsman tended to keep these individuals in the area for lengthy periods, with many becoming lifelong residents. When it came to supervision, many of the engineers were overseen by consulting engineers, those familiar with the process of constructing the concrete arch. Often, these consultants traveled from Chicago or New York for brief periods.

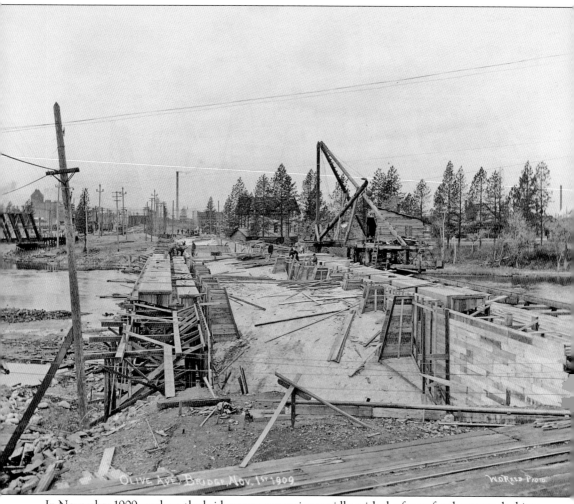

In November 1909, work on the bridge was progressing rapidly, with the forms for the upper decking seen along both sides of the structure. One of the last arches is visible at the far end of the bridge but has yet to be filled in. Once all the arches were filled with concrete, deck work was started along with the side rails. The approach of a bridge is important for aesthetic reasons; it is the part of the structure that draws one in. Early drawings held at the Washington State Archives and in the city engineer's office show extremely elaborate approach work that never made the final designs. Gigantic gargoyles, lions, eagles, and bodacious lighting are just several of the features that were never implemented. Most of the bridges ended up with relatively generic approaches, with the possible exception of the Monroe Street Bridge on the west side of the city.

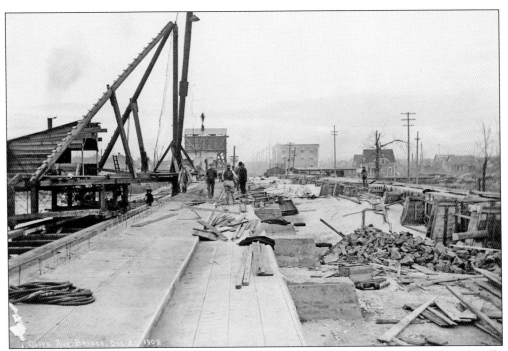

By December 1909, the forms have been pulled (far left), while work continues on the sidewalk. The traveling derrick is in the process of pouring concrete, by bucket, into the sidewalk forms. Also, note the partial roadway completion and the rebar in place for the side rails.

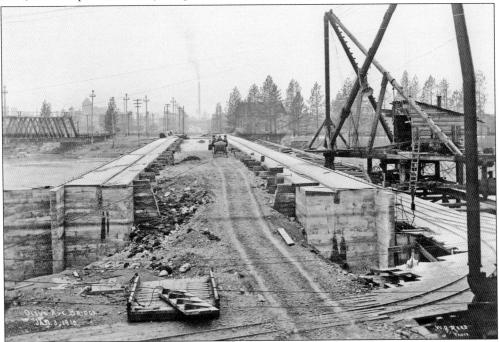

Looking west from the eastern approach, the bridge deck is almost ready to be filled and the side rails poured. At the far end of the bridge, a partial section of the side railing is in the process of curing. Work may have idled with the extreme cold of January.

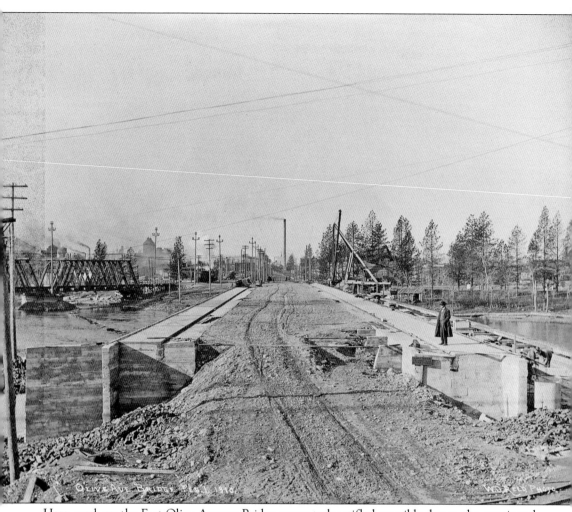

Here, work on the East Olive Avenue Bridge seems to be stifled, possibly due to the continued cold weather. This February 1910 photograph documents the fill work almost completed for the decking. Metal tie rods are in the center for added support. Eventually, the bridge had double tracking installed for streetcar use. But, for the time, the bridge was only used by pedestrians and horses, as seen with the horse-drawn wagon tracks on the decking. With the sidewalks and partial roadway completed, the side railing awaited construction. The issue of whether streetcar companies such as Washington Water Power and Spokane Traction would share in the cost of bridges was common in the early years. Washington Water Power had always shared in the cost of construction and maintenance as part of their franchise. Spokane Traction, headed by J.P. Graves, was a different story. Graves threatened to build his own bridge adjacent to East Olive Avenue if push came to shove.

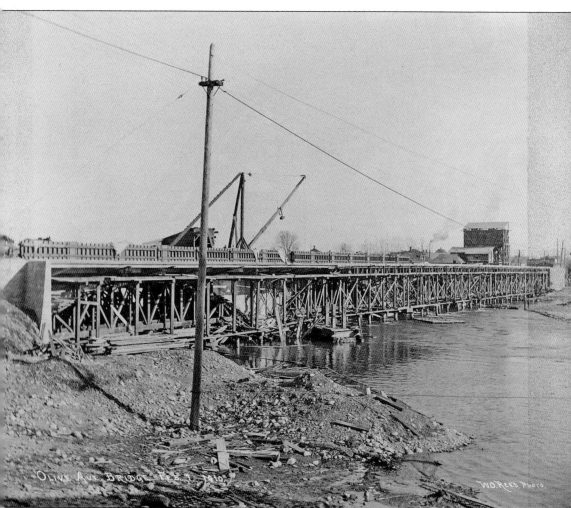

With the deck work still not completed by February 1, 1910, this progress photograph documents the completed concrete arches and the forms in place for side rails. The traveling crane (far left) is in all likelihood being used to transport concrete for the pouring of the side railing. Interestingly, the timberwork is still in place along the side of the bridge. This timberwork, while still supporting the cantilevered portion of the deck, would also serve as scaffolding for the finishing work. At the time of the construction of the East Olive Avenue Bridge, other project plans were also underway, including the Mission Avenue Bridge and the Washington Street viaduct. Soon, these projects began to exceed cost estimates. City officials pondered the fact that there would not be enough funds to start the Monroe Street Bridge, which at the time was estimated to cost more than $700,000, consuming almost half of the available bond funds.

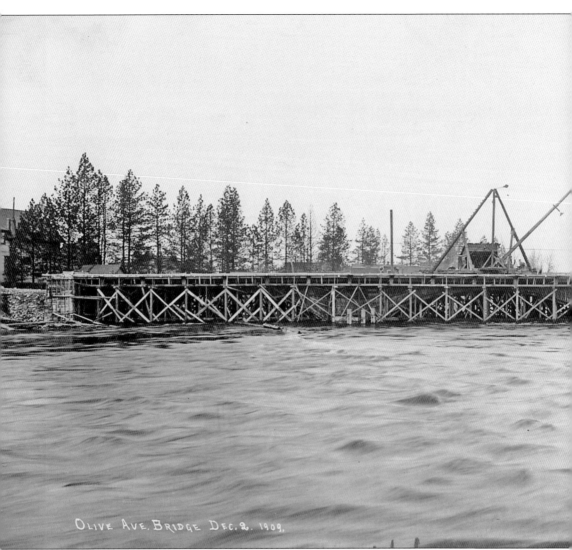

This panoramic photograph, shot in 1909 by Spokane photographer W.O. Reed, manages to capture the East Olive Avenue Bridge in its totality. Photographers like Reed were commissioned by the city to track the progress of bridge construction from beginning to end. Other photographers enlisted by the city included Charles Libby and T.W. Tolman. All three men were Spokane residences.

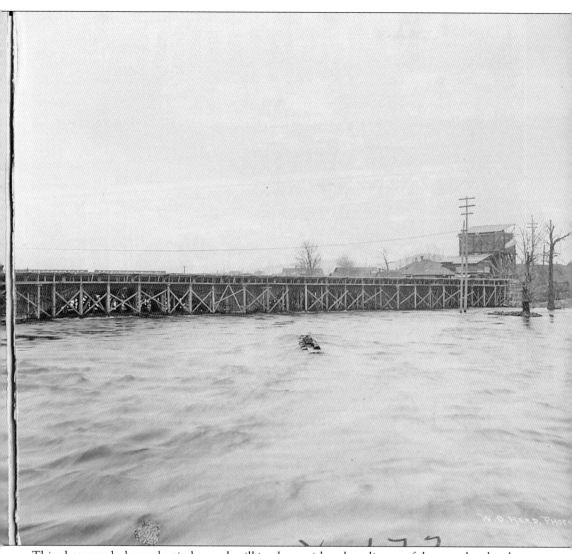

This photograph shows the timberwork still in place, with only a glimpse of the completed arches behind. As usual, the traveling derrick continues its daylong routine, transporting buckets of concrete to the worksite. A group of workers in the center are tending to the lowered bucket.

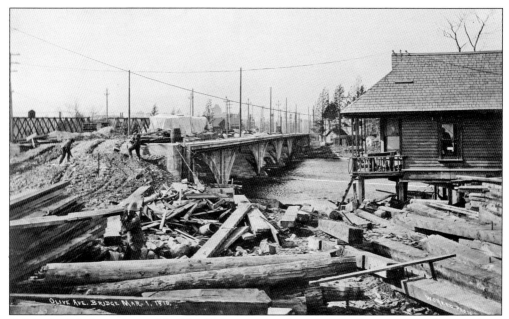

By March 1910, the timberwork had finally been removed to reveal the five massive arches stretching across the Spokane River. In this case, the arches have closed spandrels, which was common with such a low-profiled mass. Workers in the foreground are stacking the now-dismantled timber. The only work left was finishing the approach, decking, and side rails.

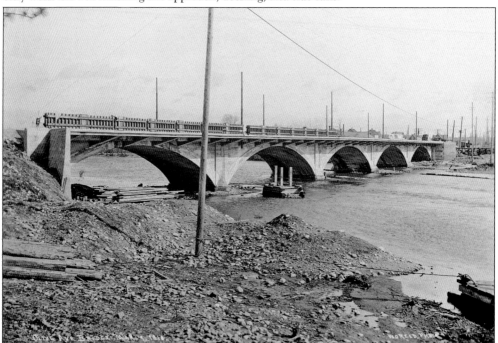

Still not completed in this photograph, the East Olive Avenue Bridge will get the finishing touches shortly, with side railing that is nearly half done. Gone are the traveling derrick, the work platform, and all timber forms. The photograph was taken on March 1, 1910, by W.O. Reed, who had served as the primary photographer for the East Olive Avenue Bridge project.

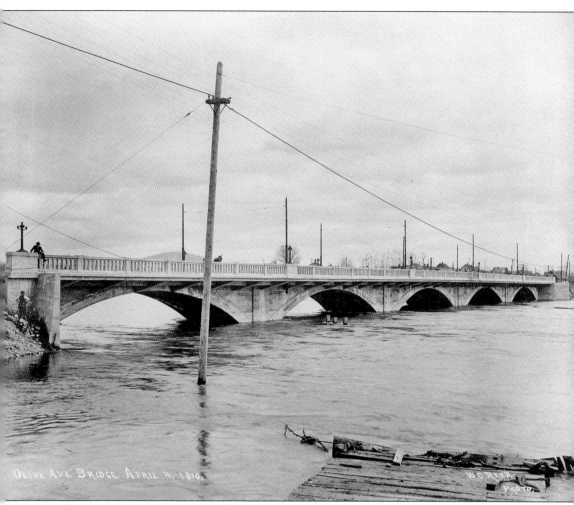

Completed in April 1910, the East Olive Avenue Bridge became the fourth of many concrete-arch bridges to be built in Spokane. Similar in many ways to the Washington Street Bridge over the north channel, this bridge had a comparable low-profile mass with closed spandrels as well as cantilevered decking that protruded the length of the bridge and supported the side railing. Its narrow arch openings within the side rails are reminiscent of the Howard Street Bridge's side railing, which features the same design. In addition, the lighting system employed atop the railing pedestals features the tri-globe arrangement similar to other bridges, like the 1907 Washington Street Bridge and the 1915 Post Street Bridge. Another very similar bridge was the Mission Avenue Bridge, constructed in 1908.

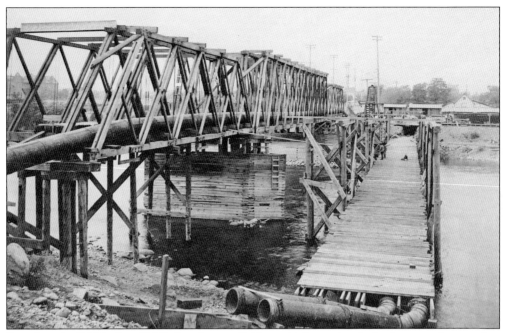

Seen here in 1908 is the old Mission Avenue Bridge, which consisted of a three-section wooden through-truss structure resting on timber piles. The timber pole bent sections are shrouded in wood as well. The platform (right) was used to construct the new bridge once the old structure was removed. A crane is also visible on the far side of the river.

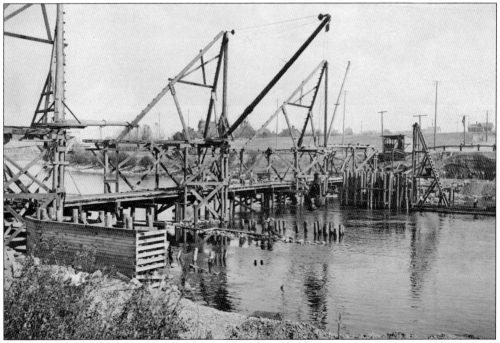

This photograph from the west bank captures the nearly removed old Mission Avenue Bridge, with the construction platform behind it supporting three mounted construction cranes. Remnants of the pier and the old foundation works have yet to be removed.

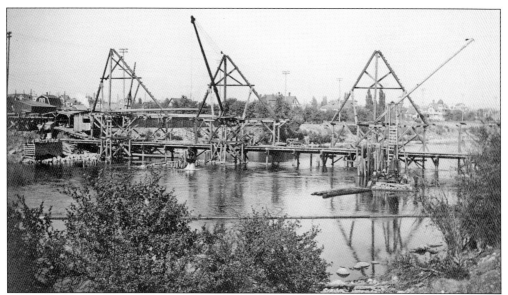

This view from the east bank of the river, looking opposite the previous photograph, shows the setup of the donkey engine. The donkey has a small crane attached for the removal of the piers that are still in the water. The procedure for the dismantling of the old bridge was very similar to that of the East Olive Avenue Bridge.

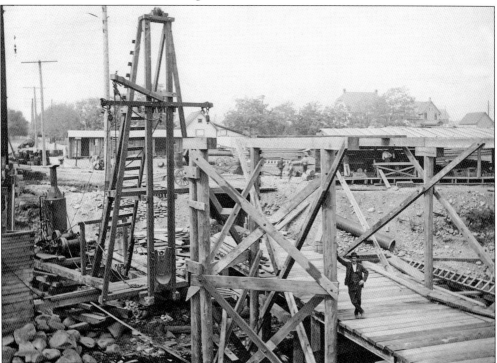

This view, taken from a pier from the old bridge, shows the donkey engine (far left) set up for the task at hand. Interestingly, these donkey engines could be found in the far reaches of Alaska, where they were used for scraping out gold deposits. One popular manufacturer at the time was the Sedro-Woolley Iron Works in Sedro-Woolley, Washington.

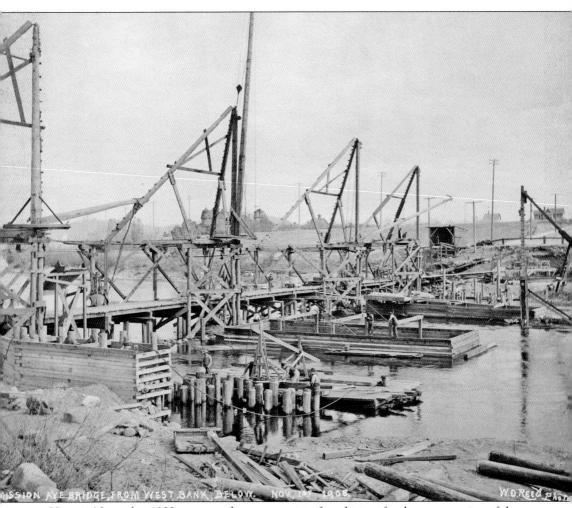

Here, in November 1908, crews work to prepare pier foundations for the construction of the new five-span concrete-arch bridge at Mission Avenue. In the foreground, the old pier structure is contained within the wood-constructed form. The form includes not only the numerous pilings, but also rubble rock, used for support. The new, larger foundation forms (center) are in the process of being built for eventual concrete pouring. A fixed derrick is positioned in front each of the new formworks to facilitate the transfer of concrete and other material into the work area. In addition, the ever-present donkey engine (far right) is in place as well. Unlike the work on the East Olive Avenue Bridge, the Mission Avenue project utilized four individual cranes instead of a single traveling crane. Larger bridge projects would soon resort to the use of overhead lines to transfer material to the work area.

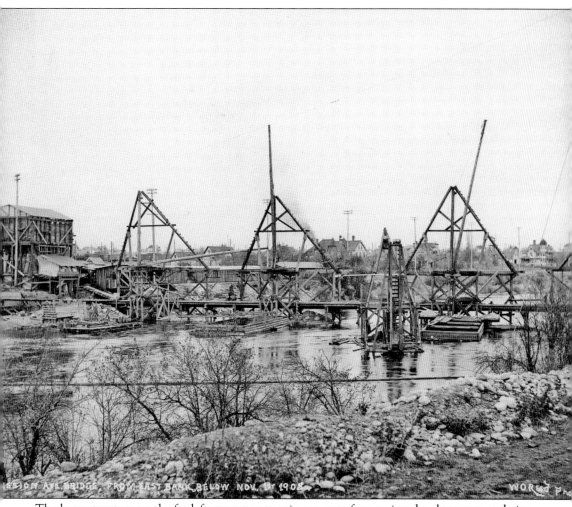

The large structure on the far left was set up to mix concrete for pouring the abutments and pier foundations and wherever else it was needed. A small ramp leads from the structure onto the work platform. This setup enabled the concrete to be transferred via cart to the awaiting buckets, where it was lowered by crane into the forms below. Again, the photograph demonstrates the use of four different derricks, one for each foundation pier to be worked. It is hard to imagine, but most of the work done on these bridges involved a lot of hand labor. Even so, the structures were usually completed in record time. When the Monroe Street Bridge went through restoration in the early 2000s, it took more than two years to complete—even with the use of 21st-century technology.

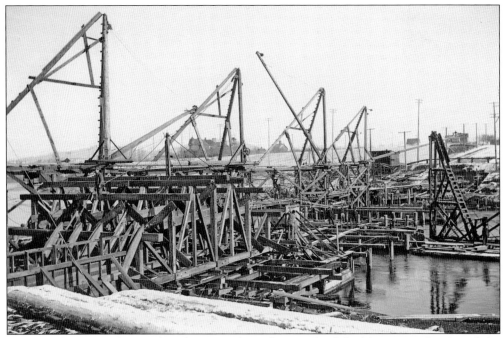

By December 1908, the pier foundation work on the west bank had been completed, and the falsework for the arches was ready to begin. The first arch's falsework (far left) is in the process of being constructed, with the large timber members being bolted into place. The cross pieces were usually 10 inches by 10 inches thick, with bracing material that was somewhat smaller.

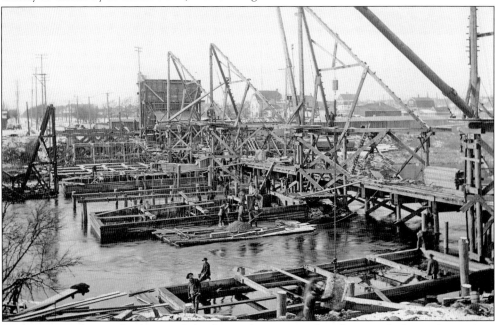

Looking from the east bank toward the first arch segment, this photograph shows the work in full swing. The month of December gives crews more time to work, as the river is even lower than it was the month before. Water must be removed from the remaining pier forms in order to pour the concrete.

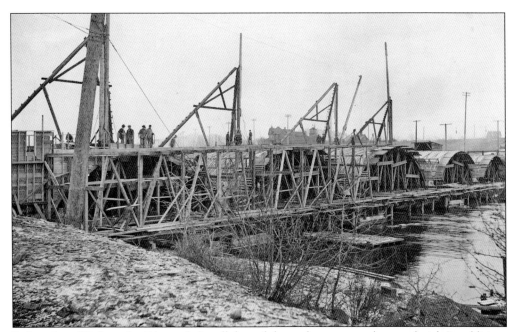

In less than 30 days, the falsework for all five of the arches was nearly completed. In addition, another piece of formwork had been put in place for the eventual deck work, which took place after the arches were poured. Seen here from the west bank of the river, the crew atop the falsework contemplates the day's work.

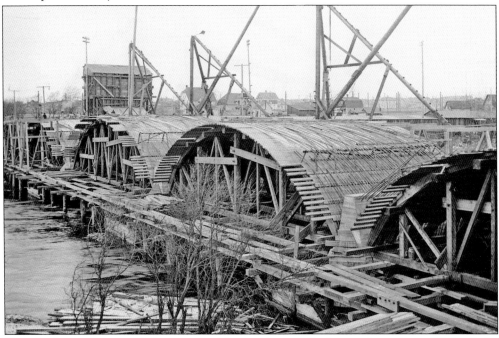

Here, looking west toward the city, the Mission Avenue Bridge is taking shape. With all the falsework done, the steel reinforcement now lies over the curved arches, extending out from strategically placed concrete foundational blocks between each segment. These blocks of concrete served as an anchor, so to speak, for the steel material.

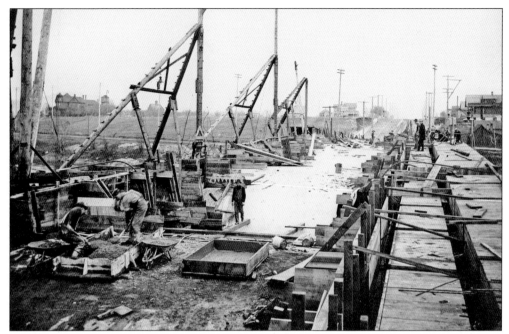

In this photograph looking east from the west end of the bridge, the focus has shifted to the deck. The crews are mixing cement at the west approach. Notice that the concrete arch work has for the most part been completed, and the work on the deck roadway foundation is ready to begin. Unlike on the East Olive Street Bridge, streetcars would not use the Mission Avenue Bridge.

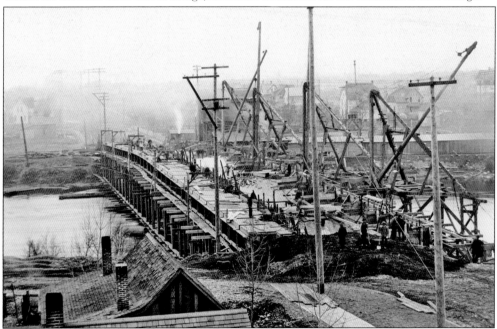

By February 1909, formwork had been put in place for the partial roadway and the sidewalks. The massive timber supports still remained along the long axis of the bridge and were now being used as scaffolding for work along the outer deck. This portion of the deck later served as support for the side rails.

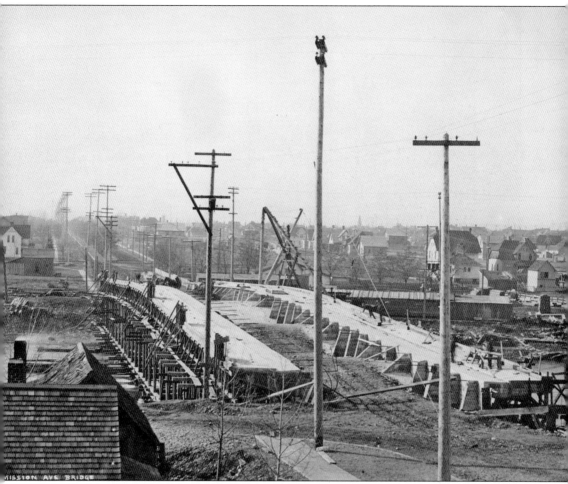

With all of the forms being removed, the Mission Avenue Bridge was nearing completion. The sidewalks and partial roadway were completed, as well as the tension rod placement seen in the center across the road deck. This area was then filled for the concrete road surface pour. Side rails were constructed on the cantilevered portion of the outer decking. This bridge actually resembled a lengthy balustrade of sorts—thin, vertical steel-rod segments between thickened concrete posts. The design gives the bridge an airy feeling above, which juxtaposes nicely with the structural arch masses below. This photograph clearly shows the forms for the concrete portion of the side railing on the left side of the bridge's sidewalk.

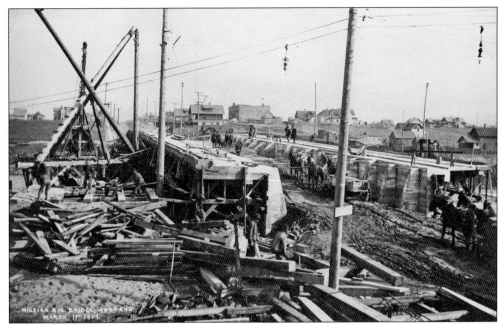

This March 1909 photograph shows the beginning of the derrick teardown along with the removal of excess timber material. All of the material and equipment used here was eventually moved to the next construction site. This period of rapid bridge construction in Spokane did not subside until the completion of the high Hangman Creek Bridge over Latah Creek, also known as Hangman Creek, in 1913.

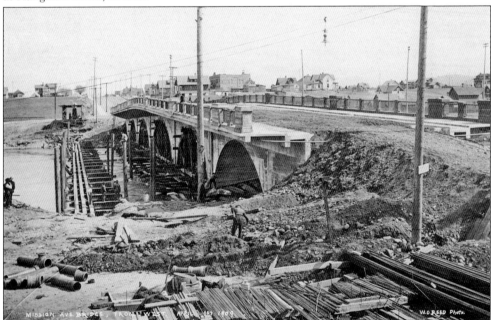

By April 1909, the last vestiges of construction began to disappear completely. Most of the formwork was down, and the interior falsework was also being removed. Only the lone donkey engine and the partial worker's platform remained. Note the completed side railings, a departure from the concrete railings of previous bridges like the Washington Street and Howard Street Bridges.

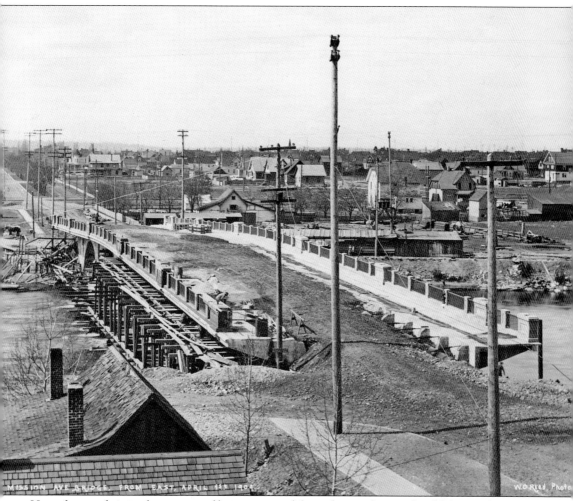

Here, formwork is in the process of being removed from the nearly completed Mission Avenue Bridge. The formwork that has been removed at the far end of the bridge reveals the cantilevered section of the deck, which is supporting the side rails. Crews continued to build up the roadway section of the bridge in order to complete the concrete pour. The timing of the bridge completion was crucial, as this photograph was taken in early April 1909, the time of year when snowmelt can create high water and cause delays. For these reasons, bridge building typically begins in late summer and concludes the following year, hopefully before April and the spring runoff. It helped that the Upriver Dam, constructed in 1894, could control the water flow if needed. The dam was approximately four miles upstream from the Mission Avenue Bridge.

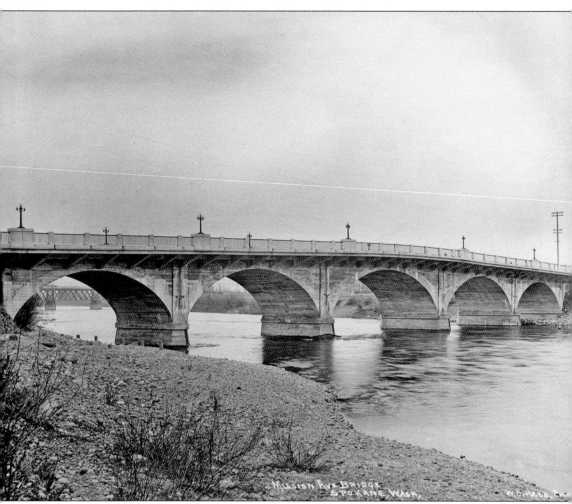

The completed Mission Avenue Bridge measured 348 feet in total length and 40 feet in width. The bridge's sidewalks were approximately six feet wide, and there were no streetcar tracks. The total cost of the bridge was between $80,000 and $85,000, and was completed well ahead of schedule. Like many other bridges in the city, this one was constructed with closed spandrels above the arches and the same type of tri-bulb electric lighting positioned atop the side rail pedestals. With the completion of both the East Olive Avenue and Mission Avenue Bridges, attention shifted to the massive undertaking at Monroe Street, at the western edge of the downtown city core. The plans for the Monroe Street Bridge had been around as early as 1906, but because of politics, they had been shelved indefinitely.

Three
THE MONROE STREET AND DIVISION STREET BRIDGES

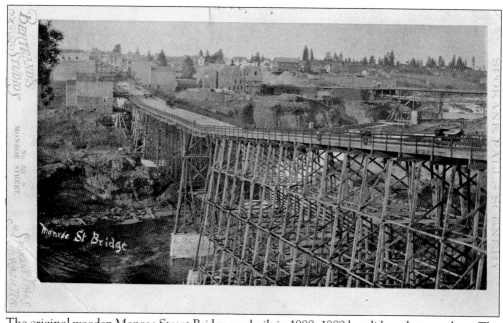

The original wooden Monroe Street Bridge was built in 1888–1889 but did not last very long. The early Post Street Bridge (upper right) is seen in the distance of this postcard, which was created by Bertrand's Studio, at 324 Monroe Street. Bertrand's was one of several photographic enterprises in the city. (Courtesy of Spokane Public Library, Northwest Room.)

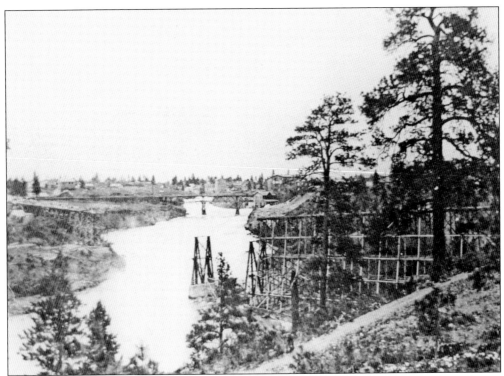

This rare photograph taken in the late 1880s shows the sheer power of the Spokane River during the high-water period. The wooden Monroe Street Bridge is seen in its early construction phase, with erected spans on each side of the river. It appears that work was paused until the water level subsided. (Courtesy of Spokane Public Library, Northwest Room.)

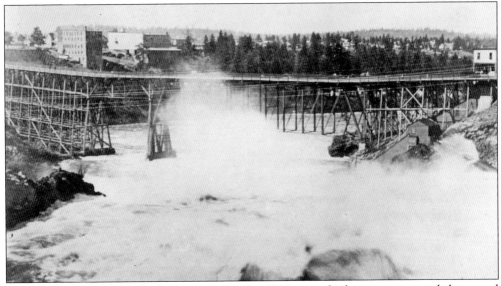

When the Monroe Street Bridge was completed in 1889, it was built to support mainly horse and wagon traffic. Citizens on both sides of the river had welcomed the early bridge, and it became a vital link between the business core and local government offices. (Courtesy of Spokane Public Library, Northwest Room.)

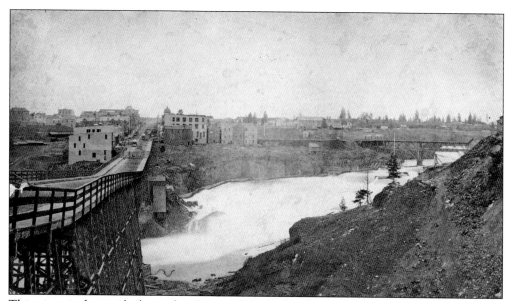

This view to the north shows the closure of the bridge due to fire. Streetcars are seen on the south approach. While this bridge was never built to carry streetcar traffic, cars did service the area down to the bridge. The Post Street Bridge is on the far right. (Courtesy of Spokane Public Library, Northwest Room.)

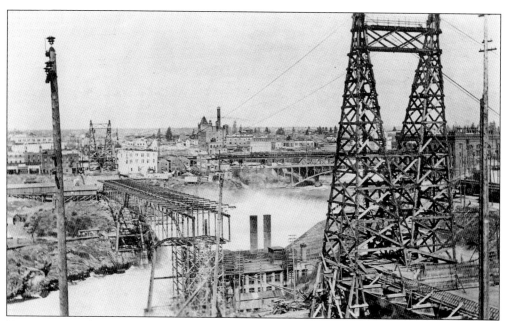

Here, in 1891, the second of three Monroe Street bridges is being erected. The steel cantilever structure was put together with the aid of an overhead crane system, whose towers are seen in the foreground and at the south approach across the river. The Washington Water Power generation plant (center foreground) was built in 1889, providing electricity to a population of roughly 23,000 people. (Courtesy of Spokane Public Library, Northwest Room.)

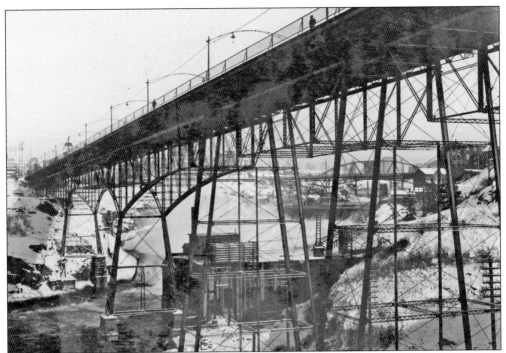

Once completed, the new steel bridge carried double-tracked streetcars and other heavy traffic. This view is to the north and gives a good look at the cantilever design, the piers, and the truss segments. The Washington Water Power generating plant is under the bridge on the south bank of the river. (Courtesy of Spokane Public Library, Northwest Room.)

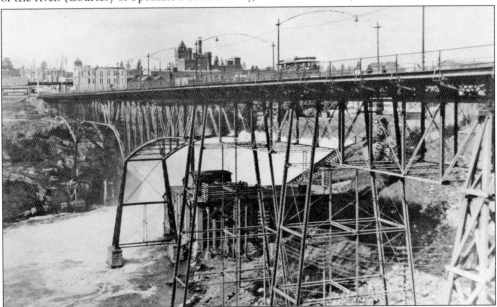

The Monroe Street Bridge was not without problems. From its earliest period, the south bank and approach was notorious for slippage. After the fire of 1889, debris from the tragedy was dumped on the south bank and into the river, creating an unstable foundation for all future bridge abutments at that location. (Courtesy of Spokane Public Library, Northwest Room.)

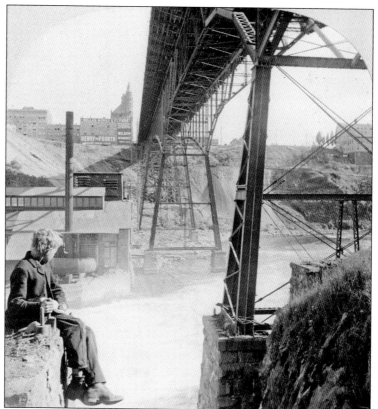

This unidentified young man enjoys the view from the north approach, looking south at the Review Building (center) and the city's business core. Still in business today, the *Spokesman-Review* is Spokane's longest-running newspaper. The building in the photograph still stands and is virtually unchanged. (Courtesy of Spokane Public Library, Northwest Room.)

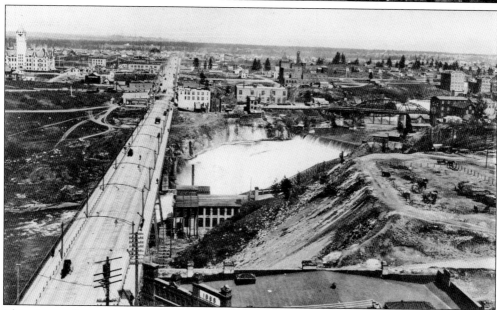

This view to the north shows the double-track streetcar lines going over the bridge, as streetcars by then shared the thoroughfare with horse-drawn buggies and wagons. Also in view are the Spokane County Courthouse (upper left) and the new steel-truss Post Street Bridge (far right), which was constructed in 1893. (Courtesy of Spokane Public Library, Northwest Room.)

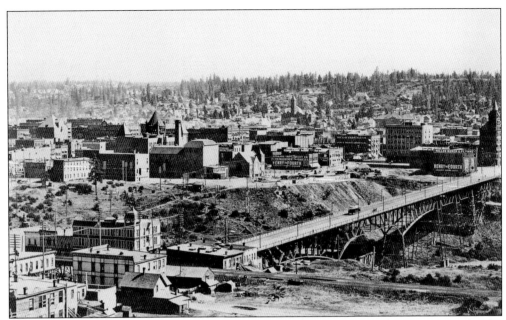

This overview of Spokane shows the ever-present Monroe Street Bridge. Interestingly, the photograph documents the change in transportation technology with the literal passing of a horse-drawn wagon by a streetcar at the center point of the bridge. The Review Building is on the far right near the south approach of the bridge. (Courtesy of Spokane Public Library, Northwest Room.)

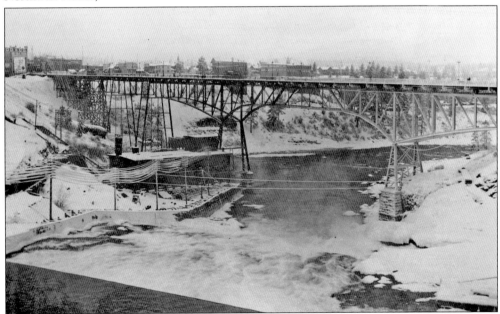

This is one last look at the steel-constructed Monroe Street Bridge before it was dismantled in 1910. When it was not yet 20 years old, the bridge suffered a partial collapse, creating a mad rush to construct a concrete-arch bridge in its place. With the Mission Avenue and East Olive Avenue Bridges completed, the largest concrete-arch bridge to date would finally span the Spokane River at Monroe Street. (Courtesy of Spokane Public Library, Northwest Room.)

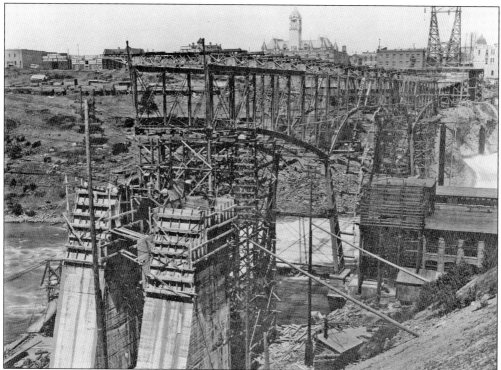

This view to the north, with the Spokane County Courthouse clearly visible in the top center, documents the "out with the old, in with the new" approach to the construction process at Monroe Street. Portions of the old steel bridge were used to begin work on the concrete portion of the new bridge, and concrete foundation piers had already been poured. (Courtesy of Spokane Public Library, Northwest Room.)

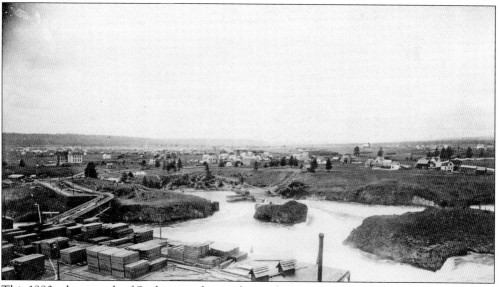

This 1880s photograph of Spokane to the northwest shows just how sparse the population was at the time. The Post Street Bridge (bottom left) was one of a few bridges linking both sides of the river on the west side of the city. (Courtesy of Spokane Public Library, Northwest Room.)

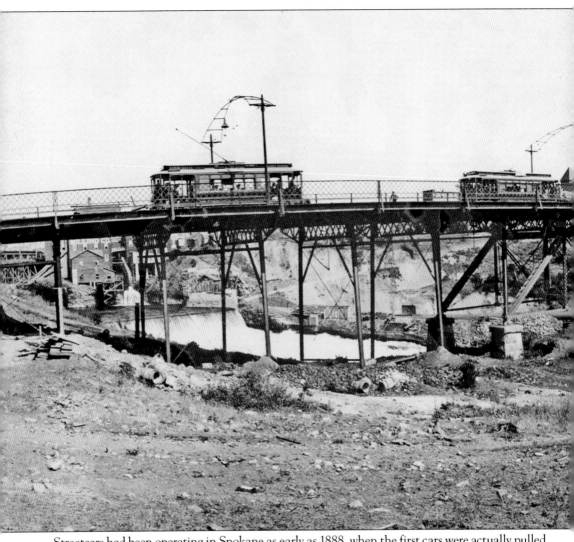

Streetcars had been operating in Spokane as early as 1888, when the first cars were actually pulled by horses. By the early 1890s, various types of street transportation were available, including steam and cable. One of the problems with the cable car was that if the cable broke, the entire line came to a standstill. Steam, on the other hand, had become a very heavy and bulky proposition. All streetcars and trolleys converted to electricity by the mid-1890s. With proximity to the Spokane

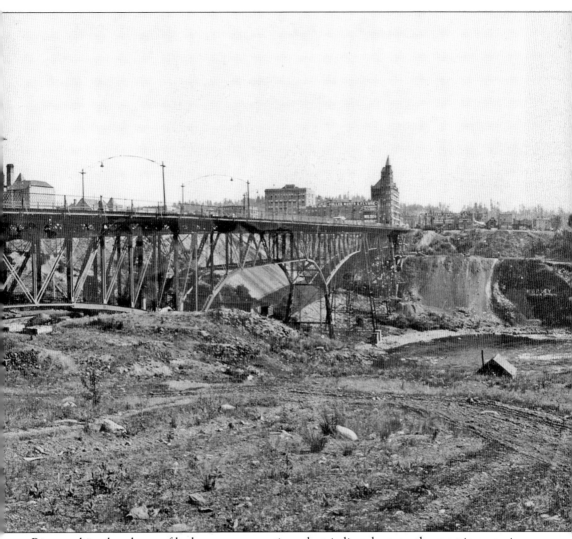

River and its abundance of hydropower generation, electric lines became the most inexpensive form of street travel and continued well into the 1930s. Some of these companies included the Spokane Street Railway, the Ross Park Street Railway Company, and Washington Water Power. These streetcars are crossing the Monroe Street Bridge. Note the overhead electric power line. (Courtesy of Spokane Public Library, Northwest Room.)

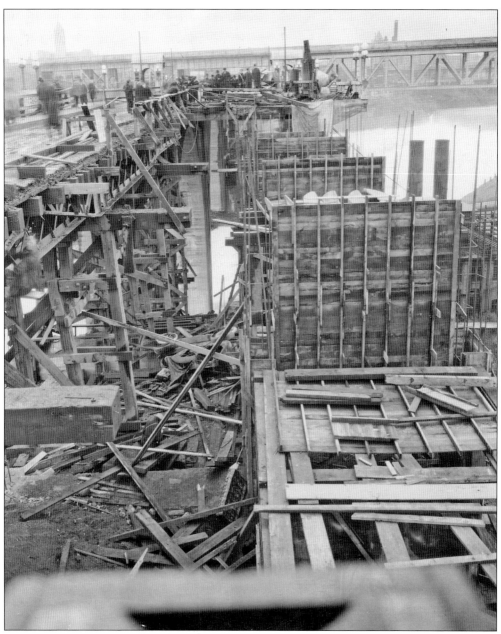

Construction of the new concrete Monroe Street Bridge began in 1910. The multiple-span structure crossed the Spokane River at a point where water travels through a gorge that is more than 140 feet high. Originally, a 791-foot concrete structure had been designed, consisting of a 281-foot center span, two 120-foot semicircular arches, a 100-foot arch, and a retaining wall to be constructed at the north end of the bridge. Later alterations in effect did away with the 100-foot arch and the retaining wall at the north end. In place of these two features was an arcade of eight semicircular arches that mirrored the open spandrels of the bridge. In this photograph, formwork is in place for the last bit of construction for the upstream arch, while the downstream side seems to be open for foot traffic. The view looks to the north with the Spokane County Courthouse in the upper left.

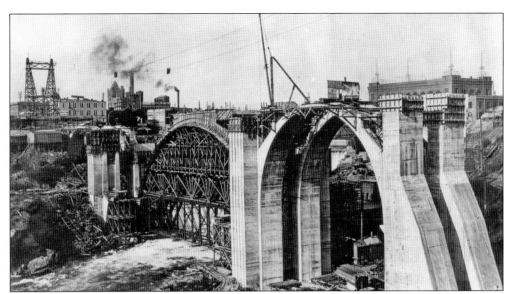

By November 1910, the first twin arch segment had been completed near the south shore, while the second segment, or center arch, was having the falsework put in place. Note the overhead lines and the construction tower at the north end of the bridge. These towers had been constructed from parts of the old steel bridge. (Courtesy of Spokane Public Library, Northwest Room.)

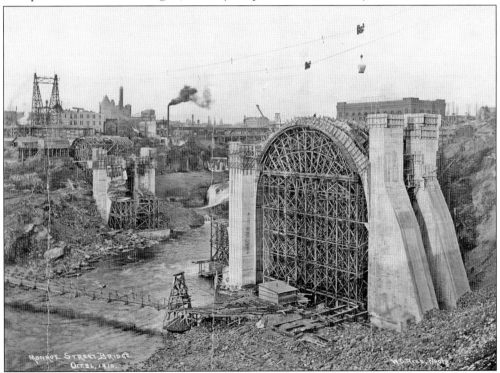

This project photograph, taken by W.O. Reed in late October, shows the bridge before the construction of the falsework for the center span. High above the worksite, buckets for concrete are being swung to the awaiting workers below in order to fill the arch forms. The workers' platform crossing the river bottom was equipped with a track for concrete carts.

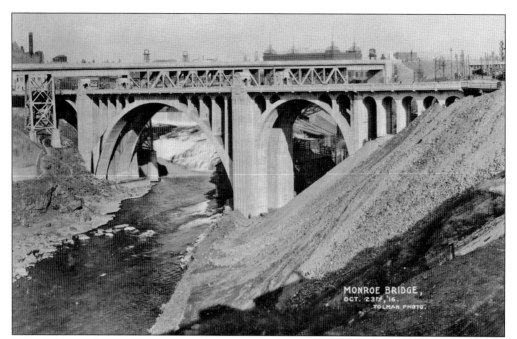

The Monroe Street Bridge was officially dedicated with an elaborate ceremony on November 21, 1911, but it was another three weeks before Washington Water Power ran its first streetcar across it. Just one foot longer than the Rocky River Bridge west of Cleveland, the Monroe Street Bridge became the longest such structure in the United States. (Courtesy of Spokane Public Library, Northwest Room.)

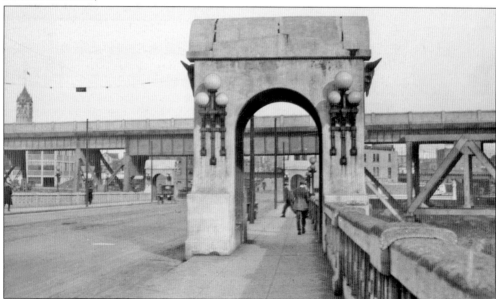

Early on, Spokane architectural firm Cutter and Malmgren rendered a variety of drawings, each featuring different motifs. Cutter's proposed ornamentation included cast-concrete profiles of American Indians. For some reason, this plan was scrapped in favor of bison skulls—two on each pavilion, four facing the roadway, and four facing outward over the river, providing a Western motif to the structure. (Courtesy of Library of Congress.)

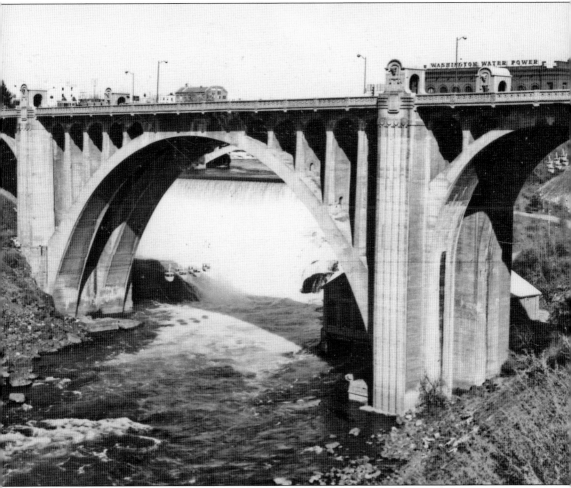

On November 21, 1911, more than 3,000 citizens gathered to witness the opening of one of the largest bridges in the world. At a cost of slightly over $488,000, the new monolith attracted the attention of the governors of Washington and Idaho and numerous other city and county luminaries. Mayor W.J. Hindley compared the structure to those built in Rome. He even went so far as to invoke the Lincolnian metaphor of bringing "north and south together." And Monroe Street was just the opening act, albeit a hard one to follow. Over the next seven years, Spokane went on a tear to produce as many concrete bridges as possible. By early 1912, the equally massive Hangman Creek Bridge project, also known as the Sunset Boulevard Bridge, was about to get underway. The year 1911, however, belonged to the Monroe Street Bridge. (Courtesy of Washington State Archives, City of Spokane, Planning Collection.)

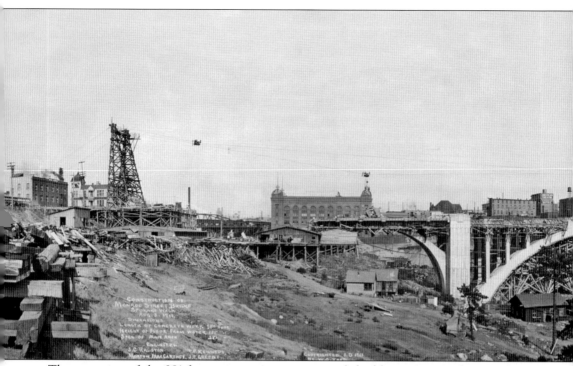

The centering of the 281-foot center span was accomplished by using a steel-truss support. Anchorages and toggles on the main span's piers allowed the erection of steel trusses as cantilevers. Early on, there was concern regarding the centering of the span. Assistant engineer John F. Greene was dispatched east, first to Kansas City to meet with Dr. Waddell and then on to New York to entertain ideas on the centering problem with renowned engineer W.H. Burr. Greene also visited the Rocky River Bridge outside of Cleveland. Meeting with Mr. Miller, a contractor

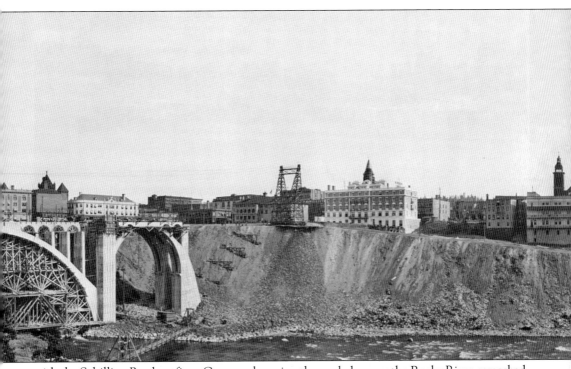

with the Schilling Brothers firm, Greene, observing the work done on the Rocky River, remarked, "They have poured the finest concrete that I have ever seen." The finished product of the main arch of the Monroe Street Bridge is a twin-rib construction, with each rib 6.75 feet deep and 16 feet wide at the crown and 18.5 feet deep and 20 feet wide at the spring, with a 36-foot spacing between the ribs. (Courtesy Spokane Public Library, Northwest Room.)

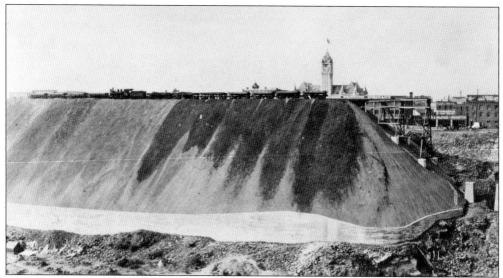

Looking north toward the Spokane County Courthouse, the massive fill in this photograph is for the construction of the Union Pacific trestle that would soon pass directly over the north end of the Monroe Street Bridge. The concrete pier work was already in place. (Courtesy of Spokane Public Library, Northwest Room.)

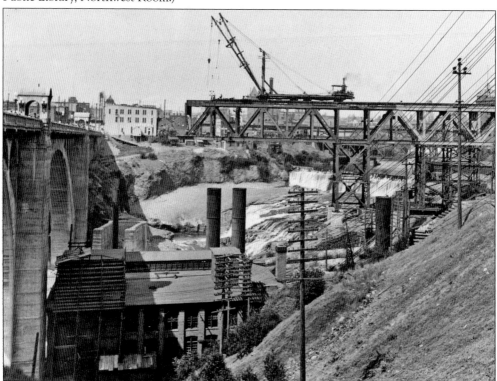

Here, in 1914, the Union Pacific trestle inches ever so close to the Monroe Street Bridge. The trestle was being built out from the upstream (east) side of the bridge. Behind the Washington Water Power generating plant (bottom left) is a concrete foundation pier for the continuation of the trestle. (Courtesy of Spokane Public Library, Northwest Room.)

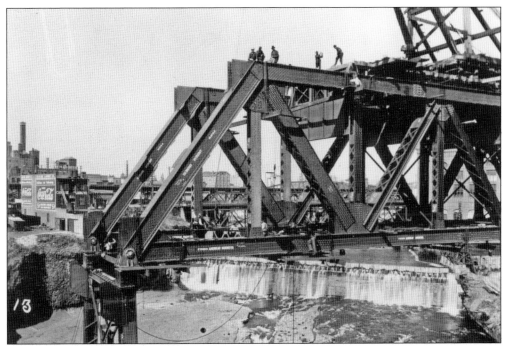

This view puts in perspective the massiveness of the steel trestle by showing the workers atop the structure. Like a gigantic Erector set, beams were lowered into place one-by-one by the crane (upper right) and then bolted to its opposing members by hand. (Courtesy of Spokane Public Library, Northwest Room.)

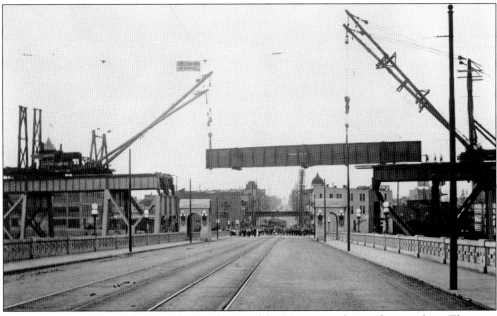

Two opposing cranes work to put the final span of the Union Pacific trestle into place. The view is to the south, where a crowd of onlookers is anticipating the trestle's completion. Not even 60 years later, the trestle was completely demolished in preparation for Expo '74. (Courtesy of Spokane Public Library, Northwest Room.)

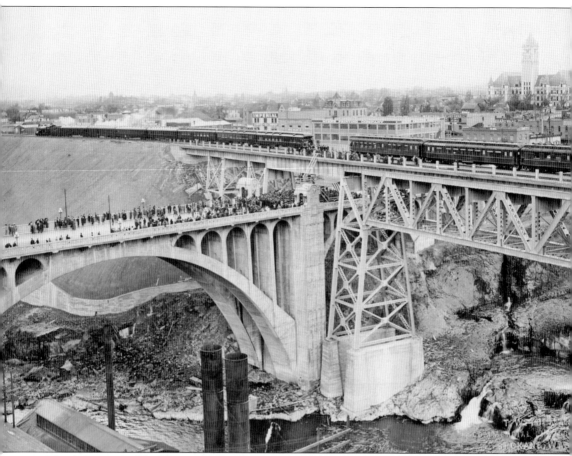

The dedication of the Union Pacific trestle took place in 1915 amongst a throng of Spokane and railroad dignitaries, as well as interested citizens, who had begun to crowd the road deck of the Monroe Street Bridge. This photograph shows the massive center span of the bridge and its slender open spandrels, which seem to be in complete opposition to the stark, utilitarian railway trestle. The two trains facing each other for the ceremony is reminiscent of the scene at Promontory Point, Utah, in 1869, when the Union and Central Pacific railroads were brought together with the driving of a golden spike. It is unlikely that this type of ceremony was replicated in Spokane, but the Union Pacific and the city clearly had a great deal to celebrate. (Courtesy of Spokane Public Library, Northwest Room.)

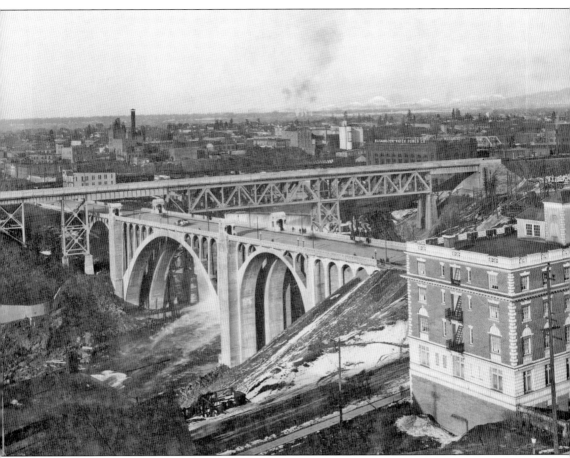

This overview of Spokane looking to the northeast shows the Spokane Club (bottom right), the Monroe Street Bridge and Union Pacific trestle (center), and even a glimpse of the Howard Street Bridge's center span (upper right). Behind the Union Pacific trestle is the old Post Street steel bridge, which was replaced in 1915 by a concrete-arch bridge. This scene drastically changed in anticipation of the 1974 world's fair. Spokane's downtown waterfront had consisted of railroad yards, stations, and everything else vital to the railroads, all of which was gone by the late 1960s and early 1970s. The trestle seen here was completely removed, and railroad traffic was diverted out of the downtown core. (Courtesy of Spokane Public Library, Northwest Room.)

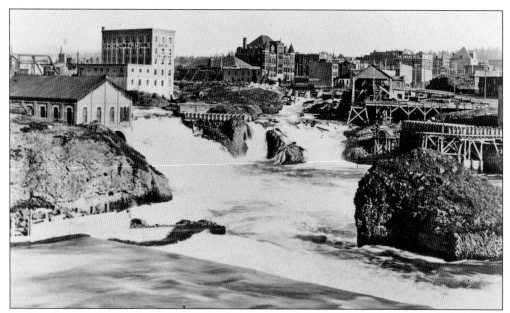

In this photograph from the early 1890s, there is everything but bridges. The city hall is in the center. The photograph was probably taken from the north side of the river near the Monroe Street Bridge. (Courtesy of Spokane Public Library, Northwest Room.)

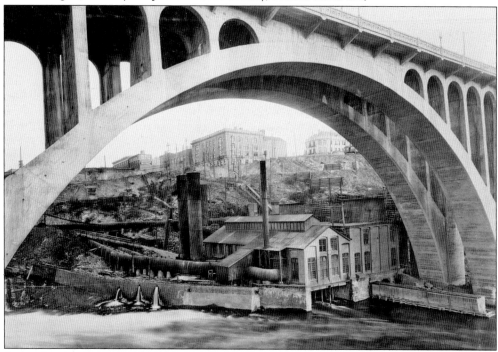

Situated under the massive center arch of the Monroe Street Bridge was Washington Water Power's Monroe Street generating plant, constructed in 1903. Up until 1992, the plant was believed to be the oldest turbine-generator power plant in the state of Washington. The plant was instrumental in the growth of long-distance power transmission. This photograph was taken in 1913. (Courtesy of the Library of Congress.)

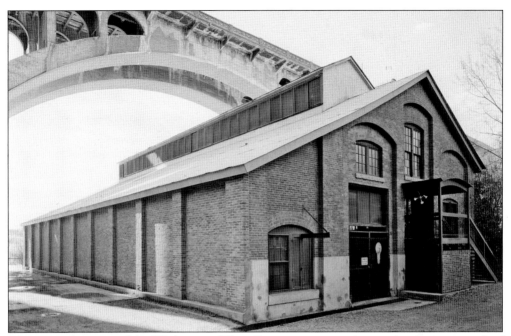

This is another view of the Washington Water Power generating plant under the center arch of the Monroe Street Bridge on the south bank of the Spokane River. The station housed units four and five, which operated on alternating current (AC). The photograph was taken in the late 1980s as part of the Historic American Engineering Record (HAER). (Courtesy of the Library of Congress.)

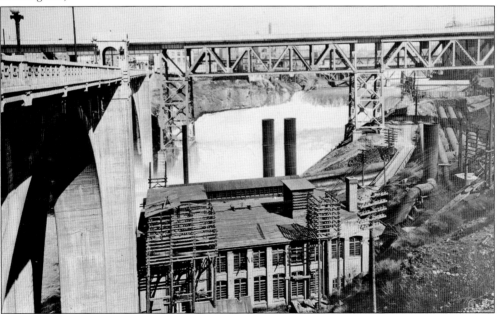

The plant is situated in the heart of downtown Spokane. This 1925 photograph affords a great view of the Monroe Street Bridge and the Union Pacific trestle that crosses the north end of the span. In the foreground, the main plant is seen with the penstocks (far right) leading into the generation station. (Courtesy of the Library of Congress.)

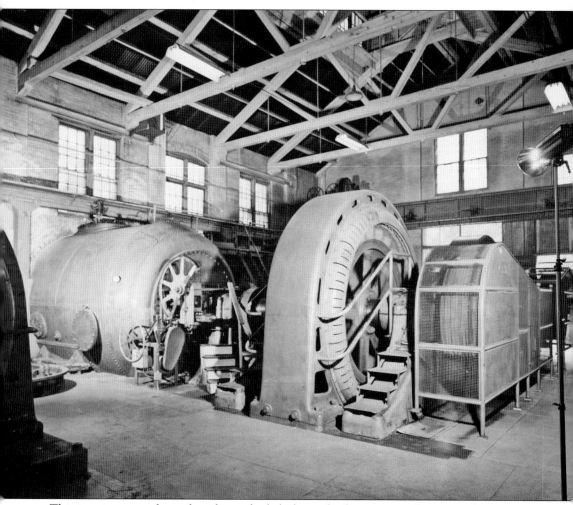

This interior view of unit four shows the belt-driven backup system adjacent to the generator. The original building that housed the generating units, constructed in 1891 and expanded in 1903, was razed in the early 1970s. The original units four and five were manufactured by the Stillwell-Bierce Company. Each unit consisted of a 4,000-horsepower turbine and a General Electric 4,000-volt AC generator. With the city's population nearly doubling to over 45,000 residents, increased power was necessary to keep up with demand. Units four and five, considered to be the most advanced hydroelectric equipment to date, were lowered into place in 1903. With the increase in power generation, the need to bring more waterpower into the system required the addition of penstocks. Originally constructed with two penstocks, two more were added in 1903. (Courtesy of the Library of Congress.)

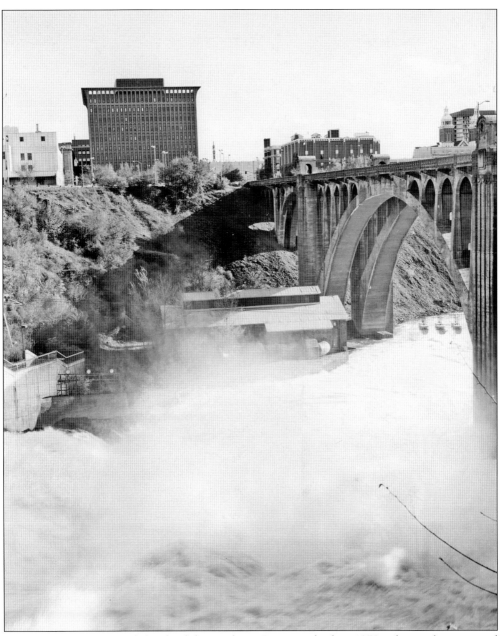

Seen here from the north bank of the Spokane River in the late 1970s, the newly renovated power plant is shrouded in the river's high water. The power plant became part of history in 1983, with its inclusion in the National Register of Historic Places (NRHP). The Monroe Street Bridge (right) had been added to the NRHP in 1975. Prior to the bridge's renovation in the early 2000s, a Historic American Engineering Record (HAER) report was generated documenting the history and architectural attributes of the bridge, one of the world's longest spans. Instead of replacing the old bridge, designers created an exact replica. The project took two years to complete and involved replacing the decking, sidewalks, railings, spandrel arches, and columns. Today, the bridge looks virtually the same, and retains all of the integrity of the original 1911 span. (Courtesy of the Library of Congress.)

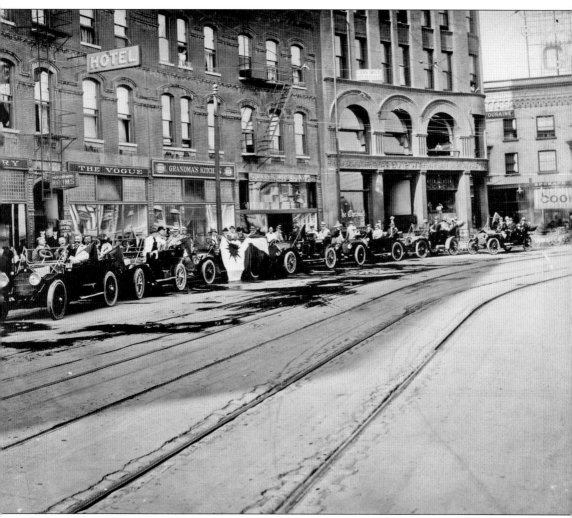

By the 1920s, the automobile had become a more economical and fashionable mode of travel, as the Spokane Club caravan parked in front of the Review Building makes clear. Though the ever-present streetcar tracks were still in use at this time, having one's own vehicle in an era of rapid change was irresistible. And there was no better way to see the city's many durable concrete bridges than from an automobile. The Monroe Street Bridge represented a major achievement in safe transportation in 1910 and began Spokane's push to build as many concrete bridges as possible over the next seven years. (Courtesy of the Washington State Archives, Spokane Historic Preservation Collection.)

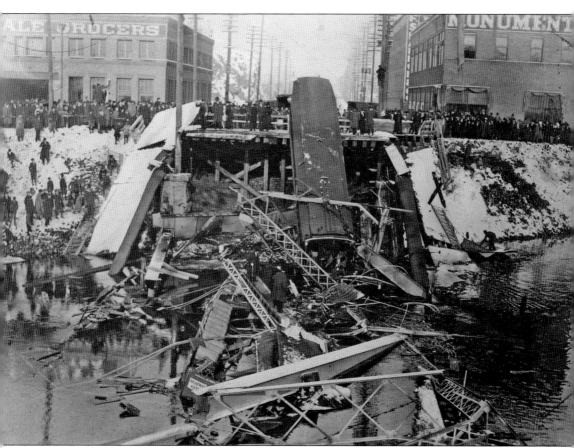

On December 18, 1915, the city of Spokane would awaken to the unimaginable. According to witnesses, at exactly 6:11 a.m., the Division Street Bridge collapsed. Conductor M.I. Davis remembers that as he was nearing the center of the span, suddenly and without warning, there was a shudder, and almost instantly, everything went black. A large steel girder from the collapsing bridge slashed across the car, cutting off everything above the seats. In the darkness, there was nothing they could do, as the car quickly sank into the icy water, coming to rest on the bridge floor as it sank to the river bottom. After nearly 10 years of "bridge frenzy," the failure of the Division Street Bridge—the worst bridge tragedy in Spokane's history—would for a time overshadow the achievements represented by the city's other bridges, and ultimately call into question the reliability of Spokane's other less distinguished bridges. The failure, according to four outside engineers, was caused by weakness in the structural steel. (Courtesy of Washington State Archives, Spokane Historic Preservation Collection.)

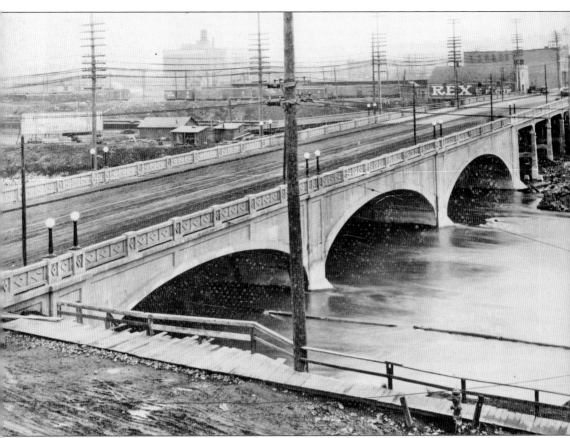

The Division Street Bridge failure indeed took its toll, killing five and injuring more than 20. At least a dozen claims were sought against the city for damages. While these issues played themselves out, the reconstruction of the bridge was being addressed. Once again, the call for concrete was echoed by the city's newspapers and concerned citizens, a call reminiscent of the early months of 1908. The approved plan for a new bridge called for a 50-foot roadway and two nine-foot sidewalks, the same as the Monroe Street Bridge. The total length of the span was 600 feet, with approximately 270 feet being the main bridge across the Spokane River and 300 feet being the viaduct portion at the north approach. This bridge would also accommodate streetcar traffic, as was the case with the older structure. The bridge was replaced again in 1994.

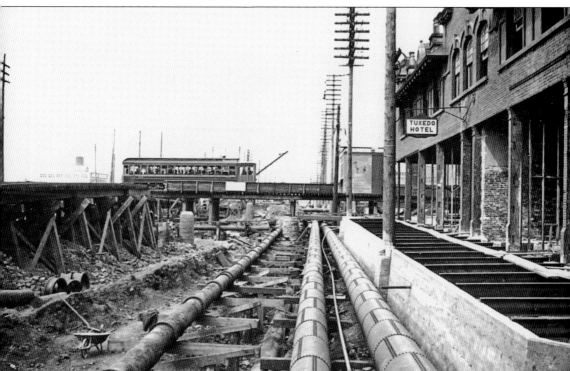

In addition to bridge construction, a major makeover to the city's downtown infrastructure was also underway. This mid-1920s scene follows the route of a streetcar heading south on Division Street. Having already crossed the Division Street Bridge, the car is making its way into the east side core of the city. Changes in the sewer and water delivery system created a maze of excavated thoroughfares. Sidewalks were being raised and new water and sewer lines were laid as the street grading changed throughout the city. Bridges also became necessary conduits to carry these lines across the river to the north side. A remodeling of the city's businesses was also under way. The Tuxedo Hotel (right) appears to be gutted and in the process of renovation. This period, from 1907 to 1930, was the city's greatest growth period.

South of the Division Street Bridge, work continued on transforming the downtown core. This photograph follows the progress on the elevation of the city's water lines for grade work on Division Street. Makeshift framework had been constructed to raise utility lines in order to fill in the new street grade. The old streetcar line (foreground) was replaced once the grade work was completed. In addition to this work, the city waterworks plant was undergoing renovations on the Spokane River. The new facility was on Upriver Drive, just north of the city. The original waterworks plant was constructed in 1884 on Havermale Island. By 1888, a new site was leased near Post Street, and eventually, by 1894, the Upriver Dam and pumping station was erected. It was later upgraded in the 1920s and still operates today.

Four

THE HANGMAN CREEK, CHESTNUT STREET, AND ELEVENTH AVENUE BRIDGES

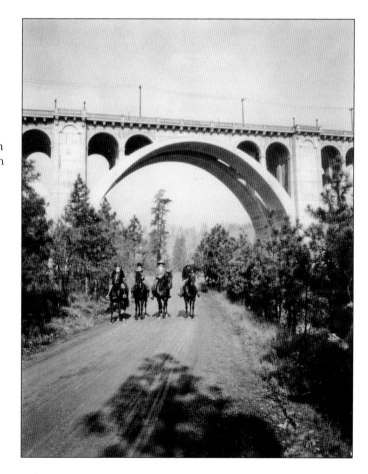

The Hangman Creek Bridge, also known as the Sunset Boulevard Bridge, crosses high over Hangman Creek, also known as Latah Creek. The names will be henceforth referred to as Hangman Creek and the Hangman Creek Bridge; see page 94 for a detailed explanation of its various names. Construction on the bridge began in 1911, setting the stage to link the city with the western hinterland and on to communities west of the Cascade Range. The east-west route would also connect the Big Bend region of Adams, Lincoln, and Franklin Counties. (Courtesy of Spokane Public Library, Northwest Room.)

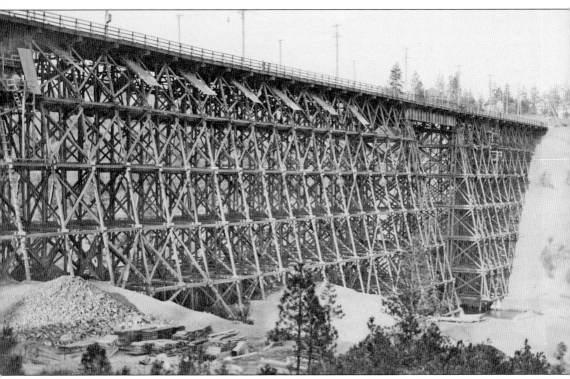

It was a frequent occurrence to see a team of horses drawing a lumber wagon and wending its way laboriously down the banks of Hangman Creek over the bottom of the creek channel on the way to Spokane. A short distance above where the creek joins the Spokane River, its banks were steep and difficult to ascend. This was one of the few places naturally suited for a crossing. When a wooden bridge was constructed at lower Riverside Avenue, it perpetuated a line of travel that undoubtedly existed long before the Spokane region was known to Euro-Americans. The Hangman Creek Bridge consisted of a timber trestle-style bridge suited for pedestrians and horses and wagons, and would never support streetcars. Plans for a new multi-span concrete-arch bridge were approved in August 1911. (Courtesy of Spokane Public Library, Northwest Room.)

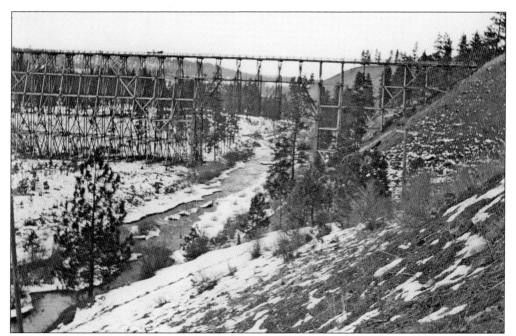

This view looking downstream to the north illustrates the vast amount of timber needed to construct the original Hangman Creek Bridge. A lone horse-drawn wagon is in the center of the bridge, making its way into the city. With the support of the citizenry of Spokane, this crude structure was soon replaced with one rivaling the Monroe Street Bridge. (Courtesy of Spokane Public Library, Northwest Room.)

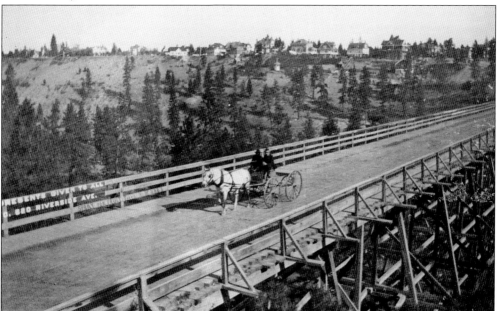

This horse-drawn traveler is met with various advertisements upon entering the city. As seen here, the bridge had no streetcar lines; it was one of the very few that did not. This original bridge was similar to the first wooden Monroe Street Bridge, built in 1888–1889. (Courtesy of Spokane Public Library, Northwest Room.)

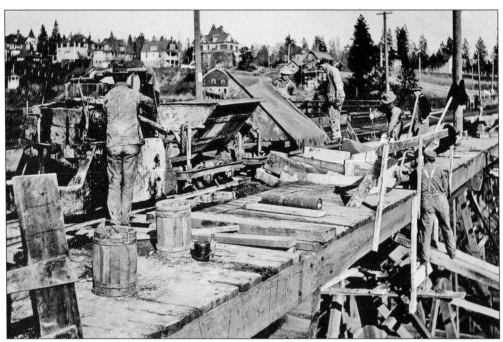

With construction of the new bridge underway in 1911, work crews utilized the old bridge as a work platform. Here, the concrete is being poured down a chute to the construction area below, in all likelihood for the construction of the foundation piers for the arches. The concrete cars were tracked into the site for an uninterrupted workflow.

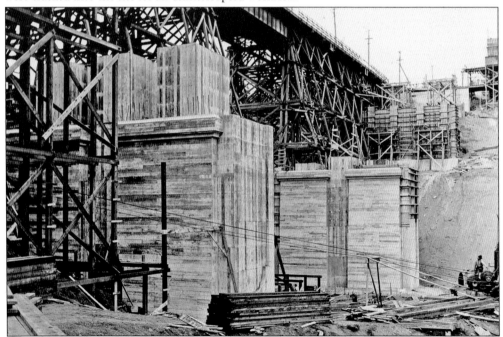

The massive pier forms seen here are being filled with mixed concrete from above. Concrete was also being poured at the top of two of the piers at the east end of the bridge as a base for the spring of the arches. Note the steel reinforcement rods protruding from the mid-pier section.

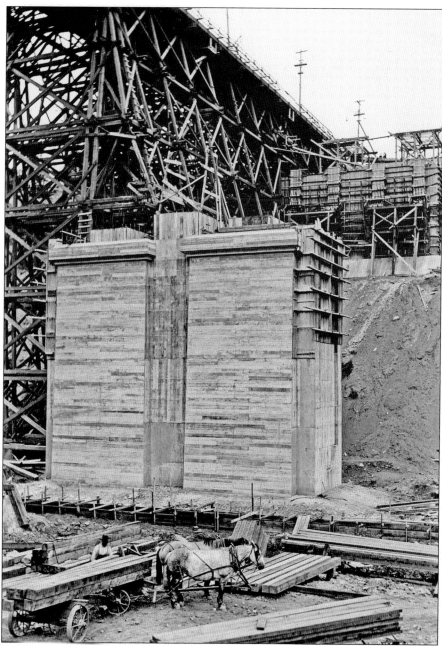

During the construction phase of the bridge, there was a concrete plant at the east end of the bridge, on a railroad siding adjacent to the mixing plant, which consisted of a storage bin for sand and rock, a half-yard batch mixer, and a cement shed of 2,000-barrel capacity. An industrial railway running along the south half of the trestle with turnouts was also installed, with hoppers for depositing the concrete in the arches and piers. All formwork for the pouring of concrete was constructed on site. Under the contract, the bridge was to be completed by July 31, 1913, under penalty of $100 for each day beyond that date. Funded by a $415,000 bond issue, the contract was awarded to J.E. Cunningham, who officially signed on October 14, 1911. This photograph illustrates the physical scale of the project.

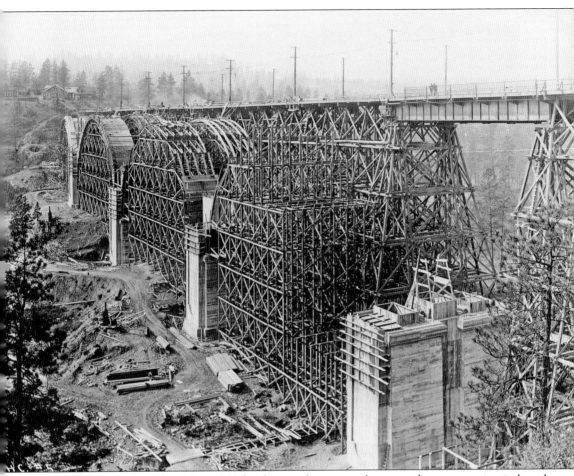

The Hangman Creek Bridge is 940 feet long and consists of seven arch-spans varying in length from 54 feet to 150 feet. The roadway width is 45 feet, with two seven-foot sidewalks and a double track for heavy interurban railway cars. Each arch consists of four arch ribs, carrying the roadway slab on spandrel columns and arches. The new bridge is located so that its centerline parallels an adjacent old timber trestle that was in precarious condition and needed replacement. The new line is curved at one end to connect two different streets on opposite sides of the valley. Unlike the Monroe Street Bridge, the Hangman Creek structure is composed of a series of Roman, or semicircular, arches. This older design was used because the semicircular form exerts a thrust at the abutment with a minimum horizontal component, an important consideration in pier construction for a bridge of such magnitude.

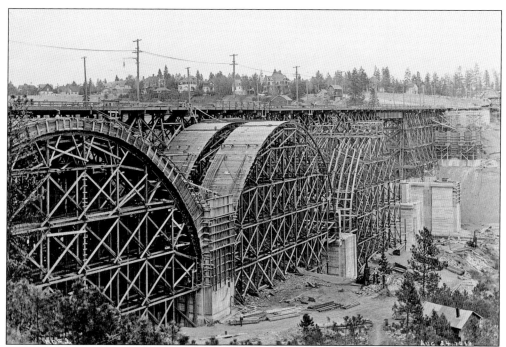

By January 1913, a total of $263,239.67 had been spent on the Hangman Creek Bridge, with a mere $25,000 of that spent on steel. More than 21,000 barrels of cement had been used up to that point, at a cost of more than $61,000. By October 16, 1913, the Hangman Creek Bridge was open and ready for traffic. Final cost estimates were tallied at more than $425,000.

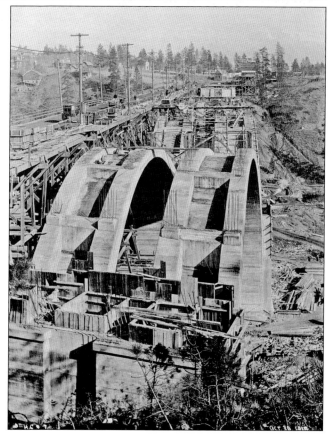

Looking across the top of four of the completed arch segments offers a good look at just how large the project was. Soon after, the arches received more concrete as well as the steel reinforcement to create the road deck and sidewalks. The old bridge (far left) was still in use, while also serving as a work platform.

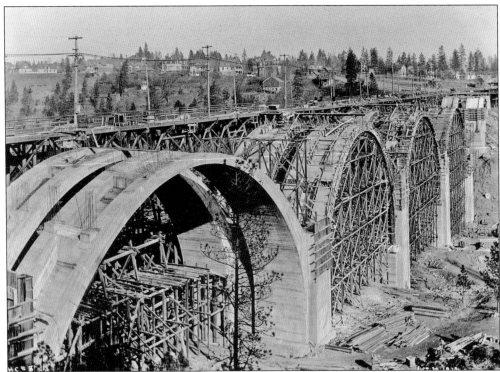

Four of the seven spans of the Hangman Creek Bridge are seen here, along with the start of the deck's formwork, particularly on the center three arches. The falsework has already begun to be removed from the near arch (lower left). The next step was to complete all deck formwork in order to start the pour.

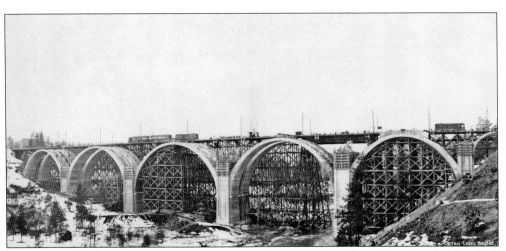

In this south-facing February 1913 photograph, the forms are still not in place for the deck and spandrel pour. However, most of the falsework for arch support has been taken down. The streetcars seen on the old bridge were part of the industrial railway. (Courtesy of Spokane Public Library, Northwest Room.)

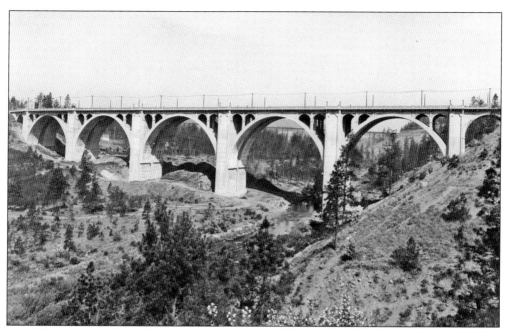

The Hangman Creek Bridge, seen here completed in 1913, was a massive undertaking. Many thought the bridge eventually overshadowed the Monroe Street Bridge, constructed just three years prior. Note the twin arch segment and the open spandrels, which are very similar to the Monroe Street Bridge. (Courtesy of Spokane Public Library, Northwest Room.)

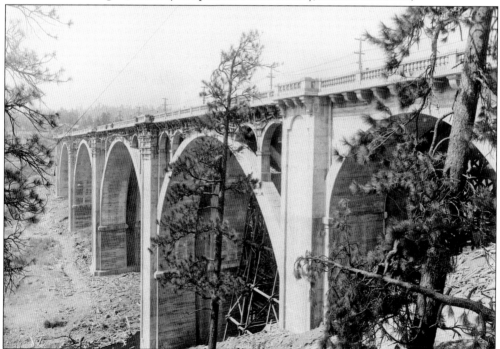

Here, some of the formwork is still in place under the cantilevered railing section of the bridge. Decorative bracketing can also be seen under the sidewalk portion of the deck, where the formwork has been removed. (Courtesy of Spokane Public Library, Northwest Room.)

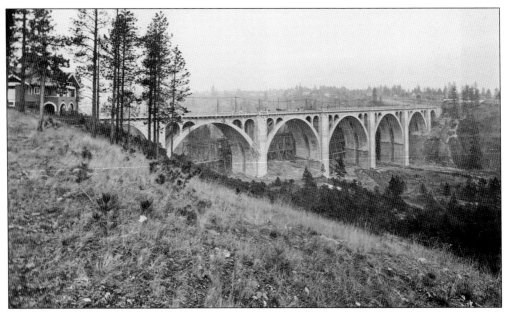

The Hangman Creek Bridge has had various names applied to it, including the Latah Creek Bridge, as it crosses Latah Creek (the other name of Hangman Creek). It has also been known as the Latah High Creek Bridge and the Sunset Boulevard Bridge. The name Hangman was derived from historical events that took place in the area during the Indian wars of 1854 to 1860, namely the infamous hanging of the Yakama warrior Qualchan by Col. George Wright.

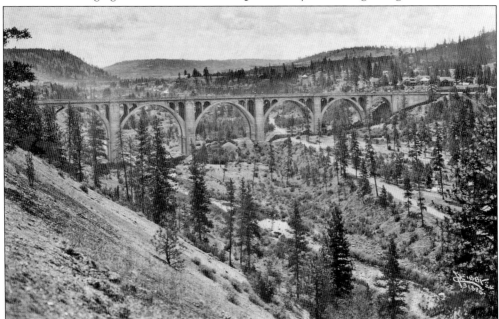

This long view of the bridge, taken by Charles Libby in 1926, shows the globe lighting affixed to the side rails of the bridge. Libby came to Spokane around 1900, working with his sister Addie in their newly established photography studio. He then spent the rest of his life in Spokane, passing the business on to his son Charles Libby Jr. in the early 1960s. (Courtesy of Spokane Public Library, Northwest Room.)

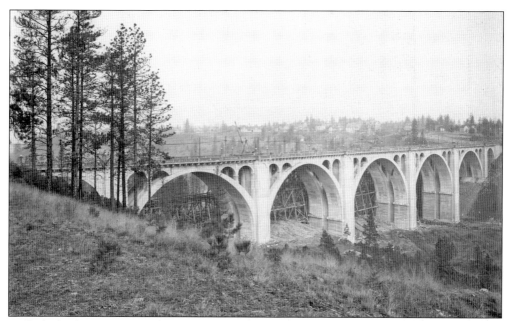

With the bridge completed and opened for traffic, a crane (center) is busy removing the remaining timber trestle structure from the old bridge. The timber was likely transported for use at other bridge construction sites. The Hangmen Creek Bridge was the last bridge of its size to be constructed in the city of Spokane. (Courtesy of Spokane Public Library, Northwest Room.)

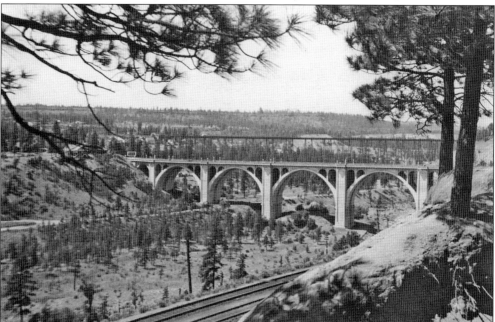

Looking north up Hangman Creek, this photograph shows the Union Pacific/Milwaukie high trestle behind the bridge. All in all, the Hangman Creek Bridge consisted of three 150-foot arches, two 135-foot arches, and two 54-foot abutment approach arches. These arches support a 40-foot roadway with two seven-foot sidewalks. The bridge was added to the National Register of Historic Places in 1982. (Courtesy of Spokane Public Library, Northwest Room.)

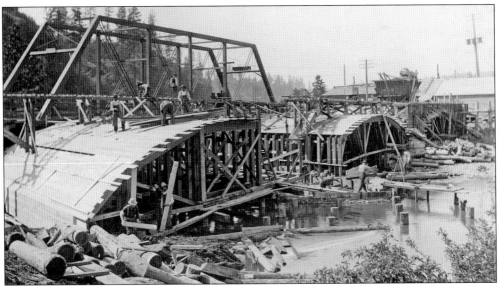

Another bridge over Hangman Creek was the smaller Chestnut Street Bridge, constructed in 1911. The new bridge consisted of three concrete arches constructed in the same manner as virtually all other bridges of this type. The old steel-truss bridge is behind it here. W.O. Reed, who was commissioned by the engineering office to record the progress of many of Spokane's bridges, took this photograph.

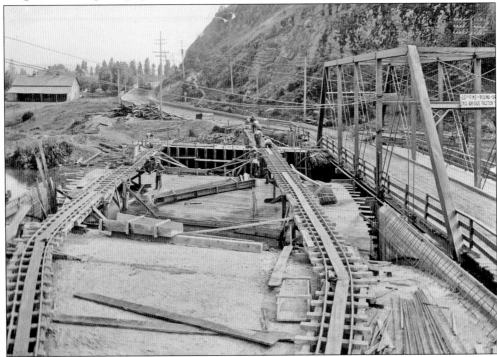

With all but one arch completed, crews work to prep the last arch and abutment. Two tracks, seen on either side of the bridge, were for the transport of concrete to the site. The little bridge measures 232 feet in total length, with a road deck width of 32.5 feet. The bridge is upstream from the larger Hangman Creek Bridge.

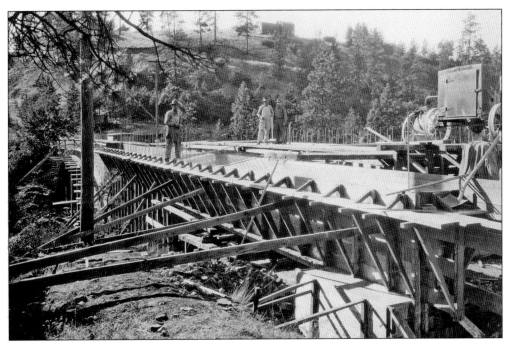

One other small concrete-arch bridge built outside of the city core was the Eleventh Avenue Bridge, between the Hangman Creek and Chestnut Street Bridges. Photographed by commissioned photographer T.W. Tolman in 1927, this was one of the last concrete-arch bridges to be built, the other being the Downriver Bridge in 1928.

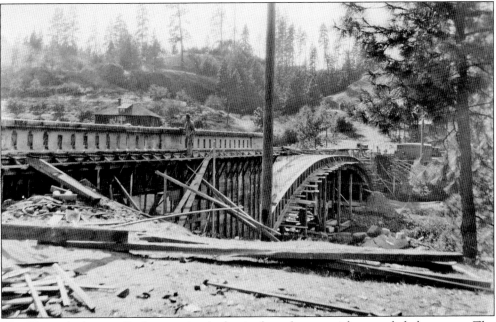

The Eleventh Avenue Bridge consisted of a single-arch span with extended abutments. The falsework seen here is minimal compared with the multi-span bridges that were built in the city. The formwork is still in place for the abutments, and the arch has already been poured. The reinforced steel protruding from the top of the arch served as support for the road deck.

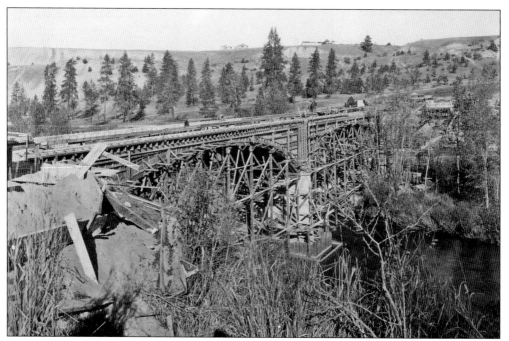

In contrast to the Eleventh Avenue Bridge is the Downriver Bridge (chapter five), constructed in 1928 on the extreme western periphery of the city. Built over the Spokane River, the span was much higher due to the canyon depth. The construction techniques seen here are reminiscent of larger spans like the Monroe Street Bridge.

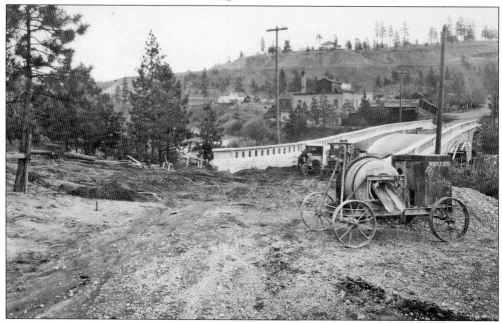

Smaller bridges often meant less manpower and equipment. The little Weller Remixer (far right) was more than adequate for the mixing of concrete for this job. At this point, the abutment forms are in place to receive the concrete, the side rails are already finished, and the single-arch span awaits fill for the road deck.

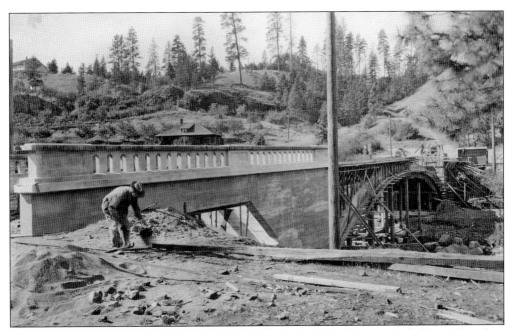

The styling of the Eleventh Avenue Bridge is much more subdued than prior bridges. This close view of the bridge's side rails and sidewall reveal very little ornamentation. By the late 1920s and 1930s, the Art Deco style became more prevalent. These styles tended to represent a cleaner, more streamlined look. Although this bridge is not purely Art Deco, it does show some emerging characteristics of the time.

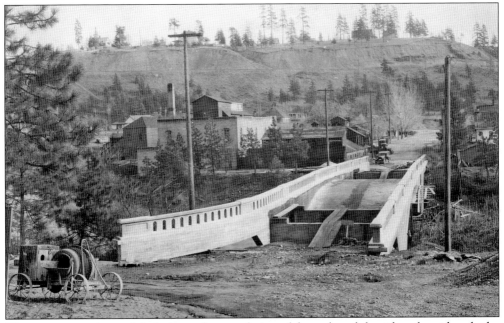

This view across the road deck shows the completion of the arch and the side rails, with only the abutment's forms yet to be filled with concrete. Once this was done, the approaches were filled in, along with the decking, in preparation for the final pour for the roadway. The Eleventh Avenue Bridge is in a predominately residential part of the city.

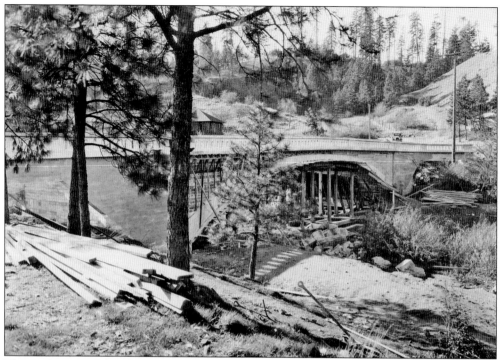

The single span of the Eleventh Street Bridge, seen here, measures just over 109 feet. The entire length of the bridge was 228 feet, with a road width of 20 feet. The contractor on the project was G.H. Weller; this was the only bridge his firm constructed. Today, the bridge is still open for traffic, and little rehabilitation has been needed other than resurfacing on the roadway.

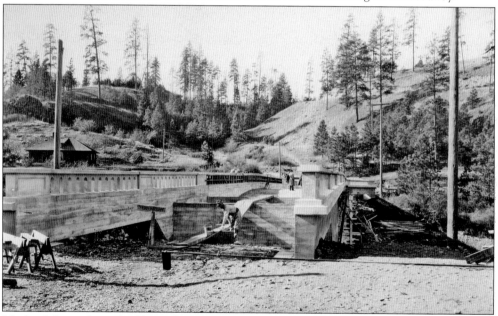

Much of the work on the Eleventh Avenue Bridge had been completed by early 1927, with the exception of the road deck, as seen here. Meanwhile, the last of Spokane's concrete-arch bridges, the Downriver Bridge, was about to be built west of the city core near Downriver Park.

Five

THE DOWNRIVER BRIDGE AND THE UNION PACIFIC TRESTLE

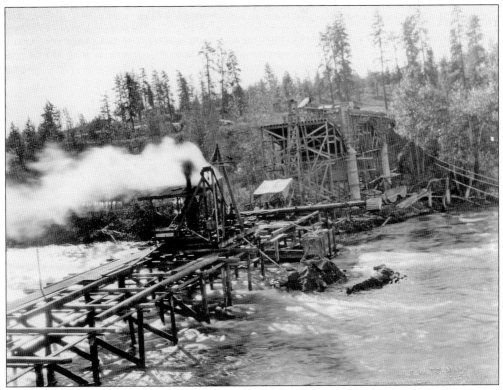

The last multi-span concrete-arch bridge to be built by the city of Spokane was the Downriver Bridge, also known as the Downriver Park Bridge, in 1928. Plans were originally submitted for a two-span structure in 1926 but were altered to a larger span design a year later. Construction of the first span is underway in this T.W. Tolman photograph.

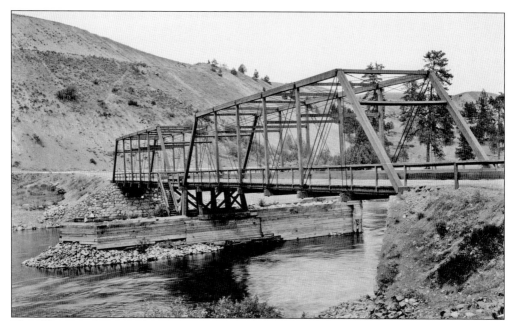

The older Downriver Bridge is seen here, a structure that was described as a combination steel-and-wood bridge in the Spokane City Council's 1926 meeting minutes. This twin-span wood-truss structure also featured a wood-planked road deck and wooden side railings. The steel suspension cables formed the main support for the deck, while the center pier support was essentially encased rubble rock.

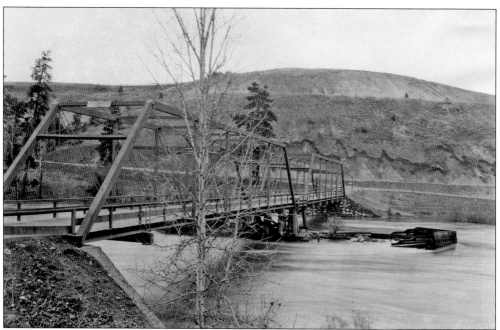

This opposite view of the old bridge shows the degradation to the center pier's foundation on the upriver side. Though the wooden forms are wedge-shaped around the rubble rock in order to divert the water flow, the problems seen here are much worse upon careful inspection. This photograph was taken shortly before the bridge's closure.

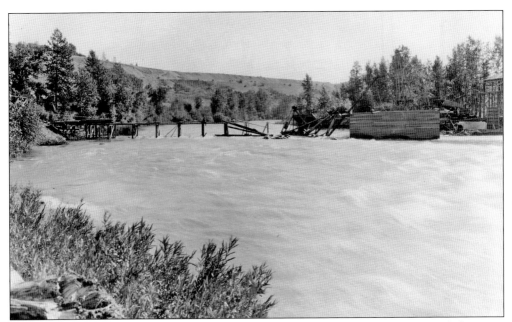

The new 1928 Downriver Bridge was built at a different location with an increased elevation. Here, crews construct the work platform across the river to enable the heavy donkey engine and crane to be put into place. The arch falsework for the future bridge (far right) is already under construction.

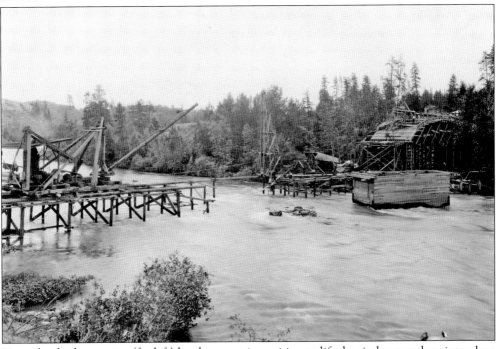

Here, the donkey engine (far left) has been put in position to lift the timber members into place for the work platform. This particular setup has the donkey engine sitting upon a sled instead of on a track-mounted unit. This sled is composed of simple round logs with a timber-framed platform affixed to the top.

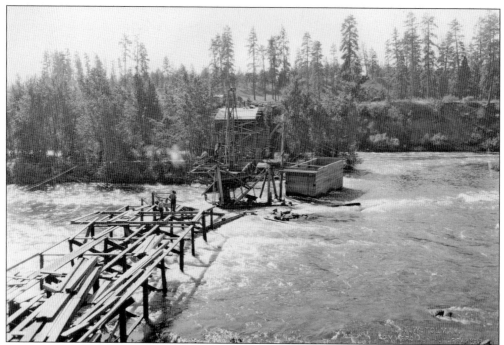

In this progress photograph, the donkey platform housing is being floated into place (center). Soon after, it was mounted on the far end of the work platform (lower left) to continue work on completing the entire length of the worker's platform. Meanwhile, the first bridge's arch form is slowly moving out over the river.

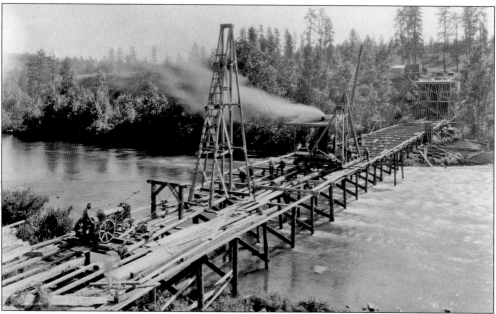

This upstream view shows the platform completed, with the donkey and crane set up in a fixed position on the platform. Unlike other bridges whose construction was carried out on the side via an old bridge, the Downriver Bridge had no such luxury, so the bridge was constructed in-line as it progressed over the river.

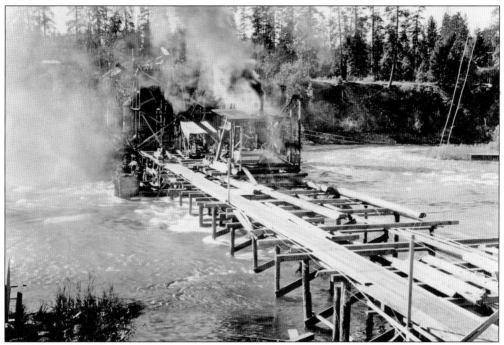

The donkey platform and housing are being pulled into place up to the face of the first arch. This pulling was achieved by using various cable lines. A tractor in an earlier photograph shows it being used with a winch in order to pull the large donkey engine. In this photograph, a smaller donkey is between the larger engine and the arch.

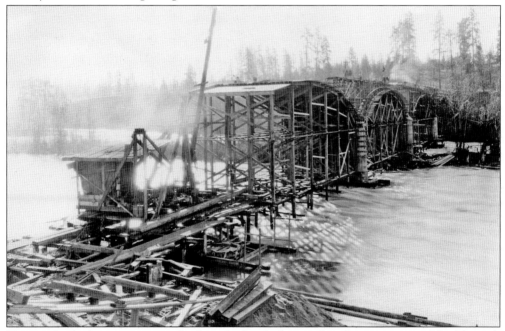

Here, as the donkey engine moves backwards, the platform ends up becoming part of the falsework for the arches and spandrels. At this point, the fourth of five total spans is being constructed. The formwork for the spandrels is also being put into place for the concrete pour (upper left).

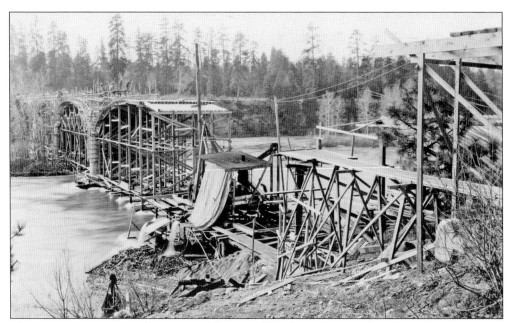

This opposite view from the previous photograph, looking downstream, shows the progression from the far end of the bridge to the termination of the bridge in the foreground. Some concrete pouring has already been started at the far end. The foundation piers can also be seen. The concrete piers have been elevated due to the bridge's elevation, which was higher than most other concrete-arch bridges in the city.

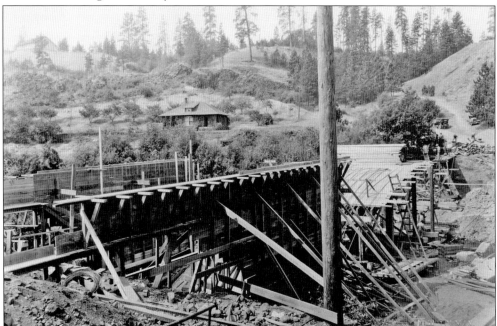

This view of the Eleventh Avenue Bridge is a good contrast with the Downriver Bridge. However, both bridges have definite similarities and confirm the city's shift from elaborate ornamental designs to simple, utilitarian plans. Though smaller than the Downriver Bridge, the Eleventh Avenue Bridge was constructed in the same manner and around the same time period.

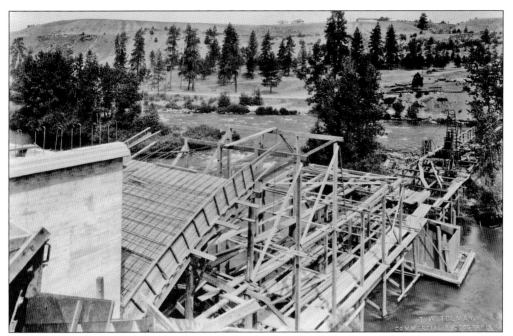

This progress photograph by T.W. Tolman clearly illustrates how these arches were put together, with timber framing, curving arch forms, and the reinforced steel creating a web over the forms that will soon become the support system for the concrete pour. One of the pier forms is on the far right next to the donkey engine.

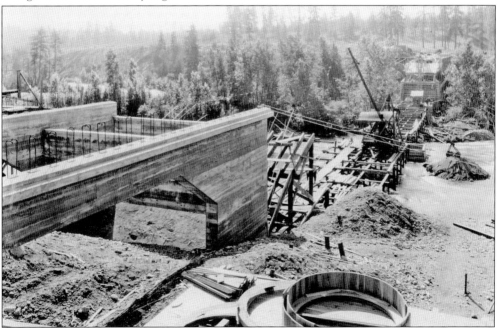

This close view of the Downriver Bridge shows the completed concrete abutment form with reinforced steel protruding from the top. Also, note the box form behind the donkey engine. This form was used to pour concrete for the foundation piers. The other forms for these foundations had not yet been constructed.

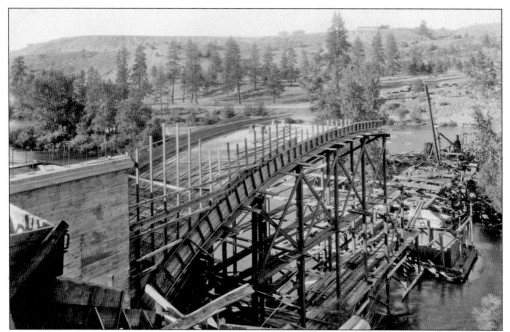

Here, the arch has been extended out from the concrete abutment and further formwork has been constructed for the spandrel portion of the bridge. The Downriver Bridge actually crossed a small island of sorts in the middle of the Spokane River, which made for a solid center pier and allowed for the longer spans.

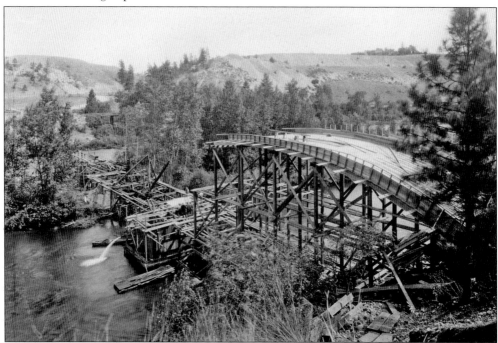

Here, the continuation of the foundation work is underway, with the pumping out of water from the forms (lower left). A total of five foundation piers were put into place, and the arches then sprang from that point, which in turn formed the base for the spandrels and road deck.

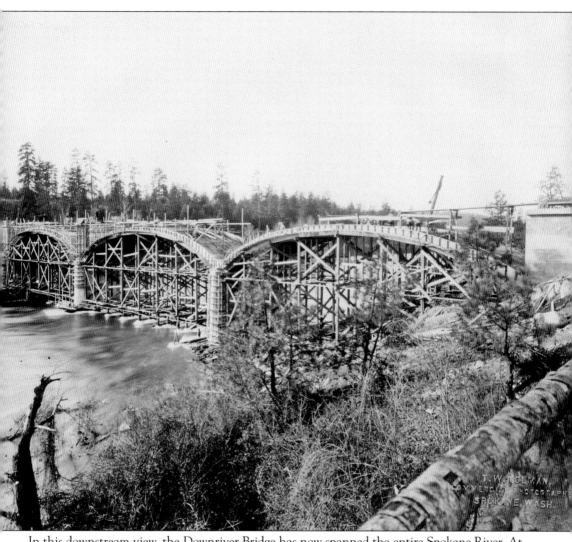

In this downstream view, the Downriver Bridge has now spanned the entire Spokane River. At this point, the falsework for the arches had been completed, as well as the laying of the steel reinforcement for the concrete arches. Both abutments had also been poured, with the approach fill to follow. Note the elevated concrete foundation piers with the arches springing from the top. The Downriver Bridge was more utilitarian in design than bridges like the Monroe Street, Hangman Creek, or even East Olive Avenue Bridges. Gone was the desire to mimic the ornamentation of bridges in Europe and on the East Coast. The Downriver Bridge actually has more in common with the smaller Eleventh Avenue and Chestnut Street Bridges, in that it shows a definite shift in the stylization of Spokane's concrete-arch bridges.

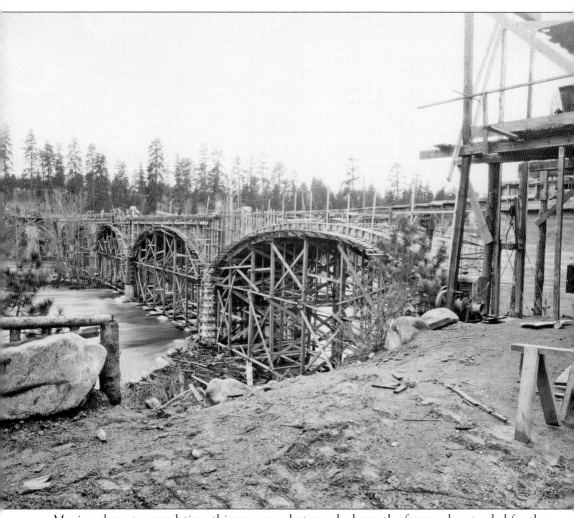

Moving closer to completion, this progress photograph shows the formwork extended for the spandrels and deck work. Wire mesh extends from the abutment (far right) out across the apex of the nearest arch, and forms still cling to the pier's foundation work. At the far end of the bridge, concrete has already begun to flow into the formwork of the arches, as well as for the side rails. At this point, the first two arch spans at the far end of the bridge are nearly completed. One of the reasons the Downriver Bridge was moved to a different location was the issue of elevation. Early in the project planning for the bridge, the Spokane Valley Power Company had their sights set on a possible hydroelectric facility just upstream from the old bridge. The company had also agreed to share the cost of the bridge had their plans been successful. Ultimately, no dam was constructed on that part of the river.

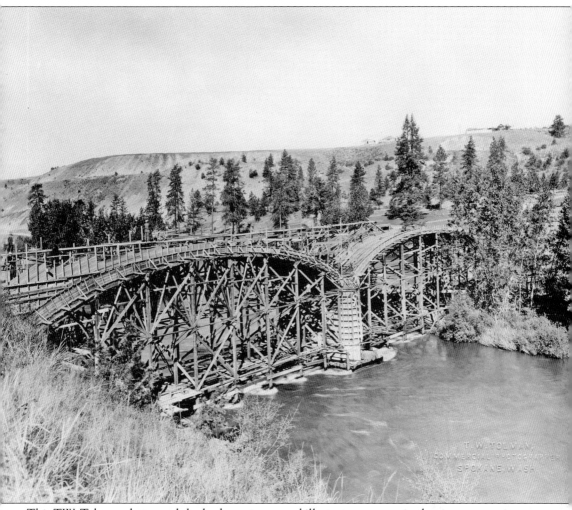

This T.W. Tolman photograph looks downstream and illustrates once again the time-consuming construction techniques of the early 1900s. The falsework is in place to support the eventual concrete pour for the arches. The center pier (center) has been completed, but it is still shrouded in the wood forms both above and below the surface of the river. The workman atop the platform is pushing what looks to be a concrete cart.

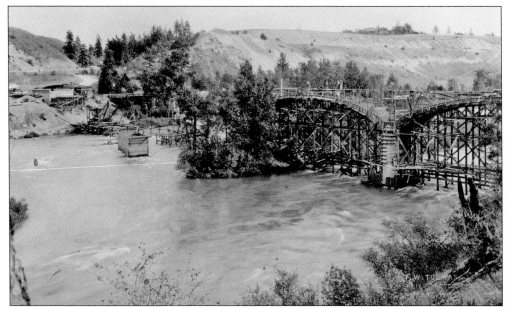

This photograph shows the laborious task of hand-pouring concrete. No buckets delivered by crane are being used here. Men wheeled in carts from a point off the bridge to collect the mixed concrete in order to fill in the arch formwork. The steel reinforcement is already in place here, draped over the arches.

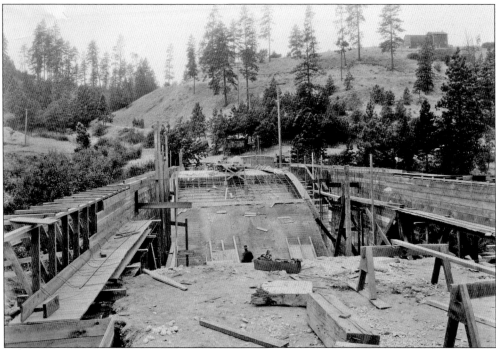

This view of the partially poured arch shows how 2-by-12 boards are employed to separate the individual pour segments, much like the pouring of a sidewalk. The platform in the center of the arch is being used to transport the concrete into the site. Once completed, the arch, or spandrel area, will also be filled with concrete to form the deck.

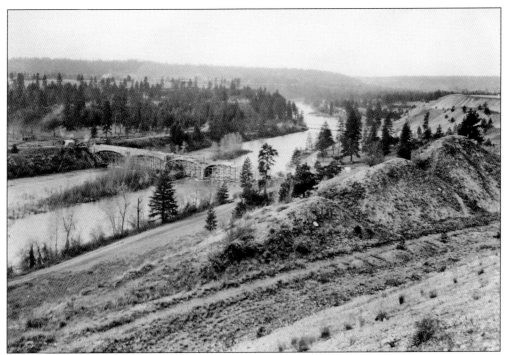

Work continues in this long view of the Downriver Bridge, with a view of the older wood-and-steel span downstream in the upper right. The first arch span (far left) is completed, with the second arch span being readied for the pour. Side rail forms are also in place on the first arch.

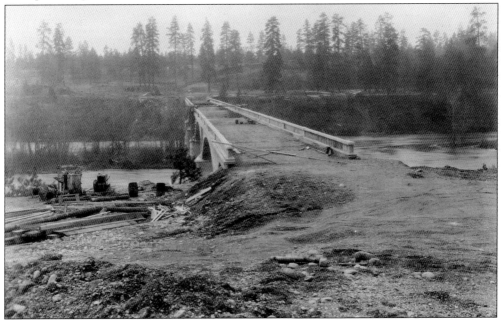

In this photograph of the Downriver Bridge, the deck fill has begun, yet beyond the fill one can still see the crowns of the arches exposed at the far end of the structure. This last concrete arch bridge built by the city is one of the most modest in design. Clean lines and without ornamentation, it became the styling of the future.

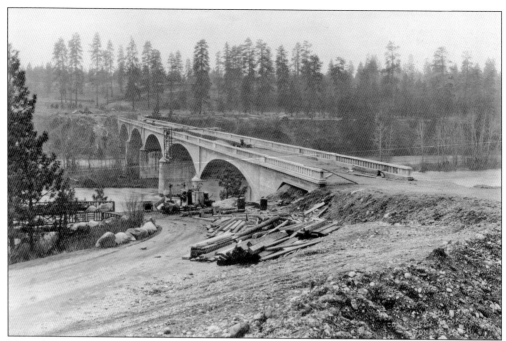

Here, the Downriver Bridge is almost finished, with all falsework and forms having been removed and only the deck work to be completed. Much of the deck has already been filled in. This bridge had no sidewalks or streetcar tracks, as it was located on the extreme western periphery of the city.

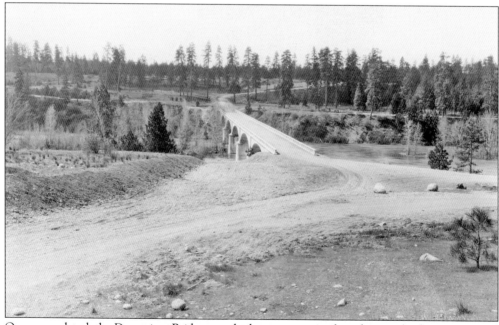

Once completed, the Downriver Bridge was the last concrete-arch multi-span bridge constructed in Spokane. The bridge was replaced in 1994 and renamed the T.J. Meenach Bridge, connecting West Fort George Wright Drive and T.J. Meenach Drive. Today, suburban neighborhoods are expanding on the north and south sides of the Spokane River.

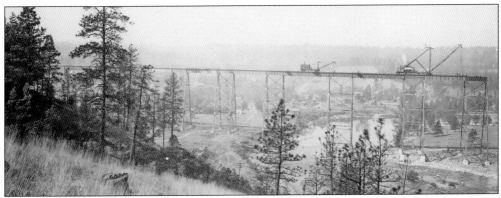

The Union Pacific trestle over Hangman Creek was constructed in 1914. Here, construction crews are in the process of laying trestle spans and rail as they move west from the city. The trestle was part of the Union Pacific's line, which merged with other lines at Fish Lake, 10 miles west of the city. (Courtesy of Spokane Public Library, Northwest Room.)

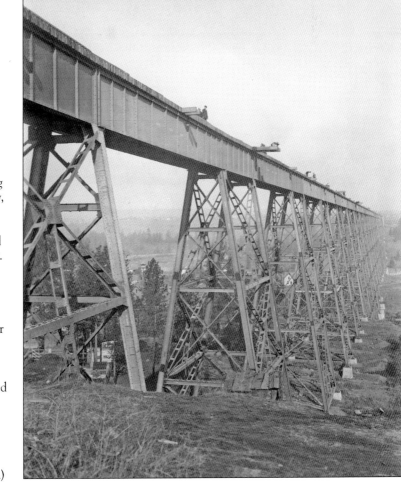

Seen here looking west from the city, the trestle was a little over 3,000 feet in length and 160 feet in height. This trestle is part of the same span that crossed over the Monroe Street Bridge after its completion in 1911. The massive steel supports are bolted to the concrete foundation piers. (Courtesy of Spokane Public Library, Northwest Room.)

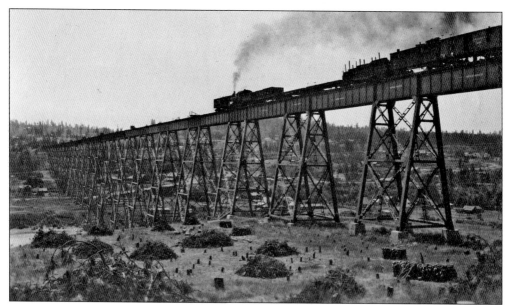

Even though it was considered one of Spokane's last remaining railroad landmarks, Union Pacific began demolition of the trestle in 1978 to make way for a new concrete-and-steel structure. This photograph shows most of the trestle's 51 horizontal steel spans. (Courtesy of Spokane Public Library, Northwest Room.)

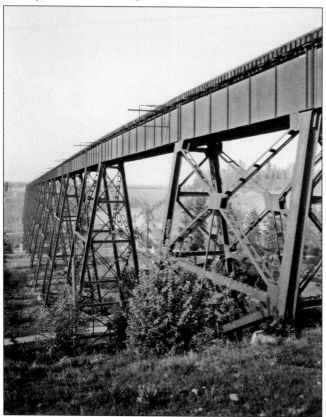

Taken shortly after its completion, this photograph shows in graphic detail the enormity of the project. After only 66 years, the trestle was replaced by a more modern structure. Much of the steel was shipped to Nebraska and Seattle, while the horizontal spans were utilized by the railroad for other projects. (Courtesy of Spokane Public Library, Northwest Room.)

Six
EXPO '74 AND RECONFIGUATION

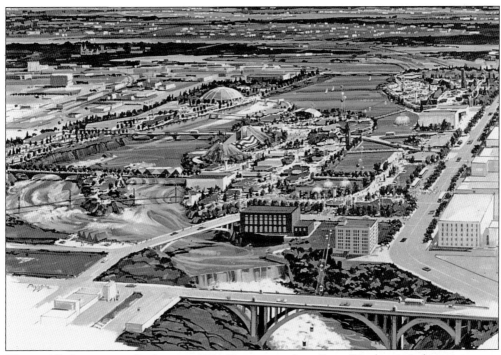

The world's fair came to Spokane in 1974. Known simply as Expo '74, the city's downtown core would forever change in the process, as this artist's rendering makes abundantly clear. The railroad yards are gone, as are all of the commercial and manufacturing buildings that once dotted Havermale Island. One of the city's bridges got a makeover as well. More than anything else, this event completely altered the city of Spokane.

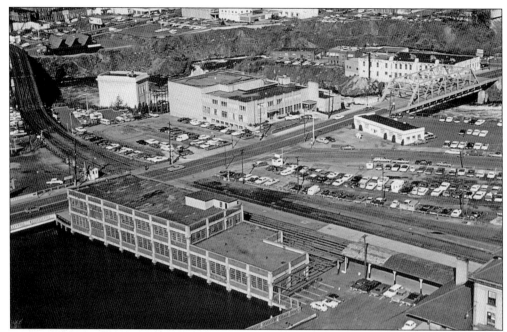

Demolition and relocation of the many rail lines began in the early 1970s. This view to the northwest shows the partial teardown of the Great Northern Railroad's elevated track (upper left). At right is the center span of the Howard Street Bridge. The 1916 Baltimore-truss span survived the downtown renovation. (Courtesy of the Washington State Archives, Spokane City Planning Collection.)

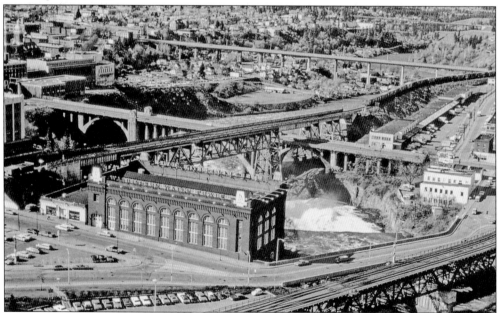

This view to the west shows the elevated track of both the Great Northern and Union Pacific railroad lines, the Post Street Bridge, the Monroe Street Bridge, and in the far distance, the Maple Street Toll Bridge, which was constructed by the state of Washington in 1956–1957 and later reverted to the city. (Courtesy of the Washington State Archives, Spokane City Planning Collection.)

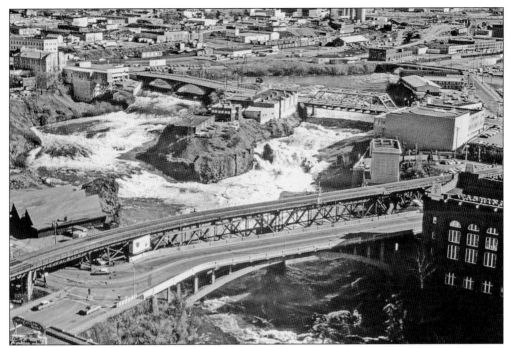

This photograph from before Expo '74 looks northeast at the Post Street Bridge (bottom) and the Howard Street Bridge. Canada Island (center) is the connecting point for both spans. Though initial Expo plans called for replacing these bridges, they managed to escape the wrecking ball. (Courtesy of the Washington State Archives, Spokane City Planning Collection.)

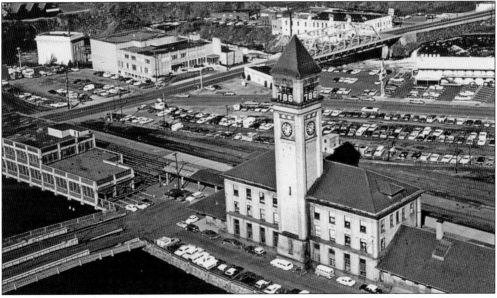

The Great Northern station (center) was eventually torn down, but the clock tower remained and continues to be a focal point in Riverfront Park today. Above the tower is the countdown to Expo '74. In the 786 days before opening day, Havermale Island was rapidly transformed. The depot was originally constructed in 1902. (Courtesy of the Washington State Archives, Spokane City Planning Collection.)

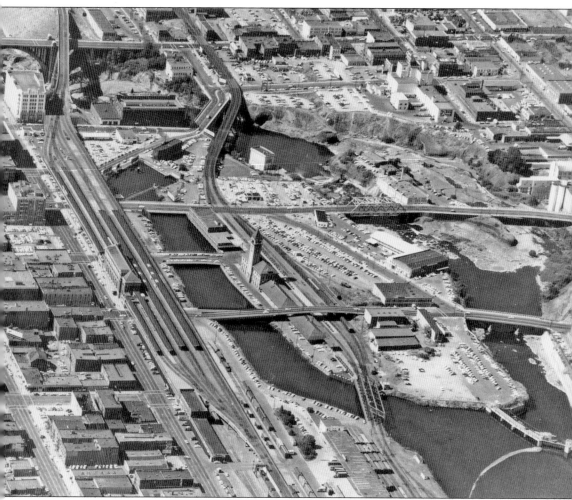

This aerial view shows the city in the early 1970s, just prior to the rail yard's demolition. Looking to the west, both the Union Pacific and Great Northern stations are seen (center), along with the Washington Street Bridge just below them. Note the elevated south-channel span running over the top of the Great Northern track and part of the station. After the rail yards were razed, the Washington Street Bridge over the south channel underwent a complete reorientation, consisting of a "Y" bridge that facilitated one-way traffic in and out of the city core. The Howard Street Bridge is in the center of the photograph. At this time, it was still open to vehicular traffic. The Monroe Street and Post Street Bridges are also in view in the upper left. Once an area serving the railroad industry, Havermale Island became ground zero for Expo '74. (Courtesy of the Washington State Archives, Spokane City Planning Collection.)

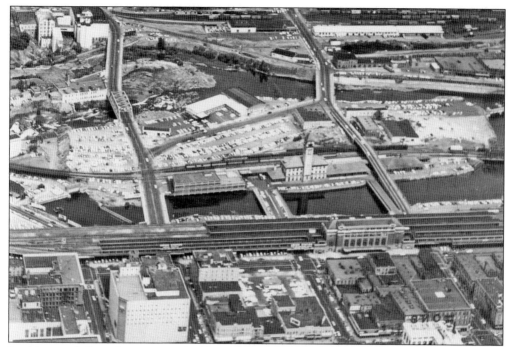

Looking north from the city core, the Howard Street and Washington Street Bridges outlasted the coming demolition and are still the main thoroughfares out of the city core across Havermale Island. With the coming of Expo '74, the Howard Street Bridge was closed to traffic and became a pedestrian bridge. (Courtesy of the Washington State Archives, Spokane City Planning Collection.)

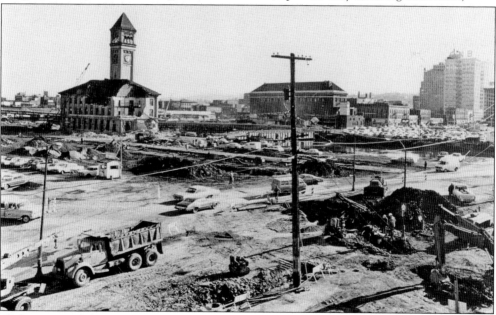

With 450 days left until the projected opening of Expo '74, crews work to demolish the Great Northern Station. Now that the trackage was removed, all that remained to be done was the razing of structures on Havermale and Canada Islands. This view is to the southeast. (Courtesy of Spokane Public Library, Northwest Room.)

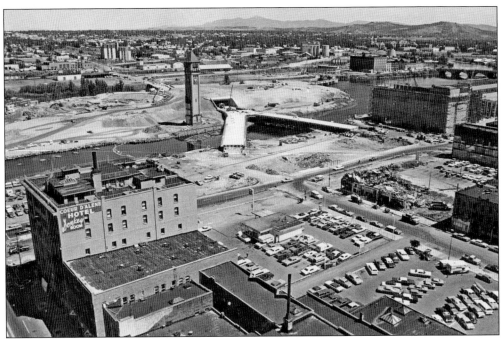

With the grounds cleared in 1973, the State Pavilion (far left) is being constructed, as is the reconfiguration of the Washington Street Bridge over the south channel. The last vestige of the Great Northern Railroad is the lone clock tower (center), displaying the countdown at 327 days until opening. (Courtesy of Spokane Public Library, Northwest Room.)

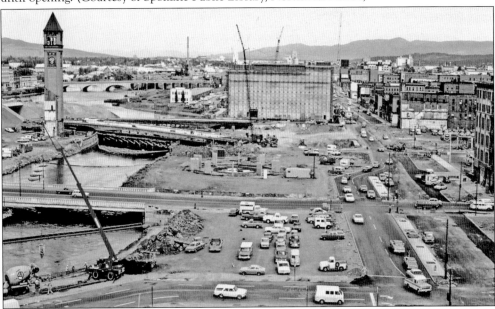

This view looking east during Expo '74 construction shows the 1930 Howard Street Bridge (left) over the south channel and construction of the reconfigured Washington Street Bridge (left center). The erection of the carousel is also underway (center), another Expo '74 holdover that is still in operation in what is now Riverfront Park. In the distance is the Division Street Bridge. (Courtesy of the Washington State Archives, Spokane City Planning Collection.)

The Washington Street Bridge's south channel span is seen here prior to demolition in 1972–1973. This close view shows the elevated span running atop the Great Northern station. After it was reconfigured, the bridge consisted of two spans, for northbound and southbound traffic. (Courtesy of Spokane Public Library, Northwest Room.)

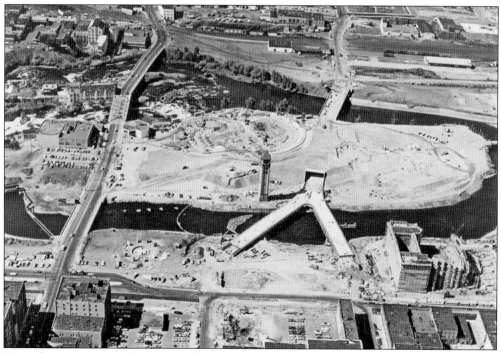

Here, the reconfigured Washington Street Bridge is under construction, with the added feature of a tunnel across the island. The tunnel was added in order to create a continuous space, as Washington Street bisected the island at this point. This also provided a place for the erection of the US Pavilion. The north span of the bridge (right) remained until it was replaced in 1983. (Courtesy of Spokane Public Library, Northwest Room.)

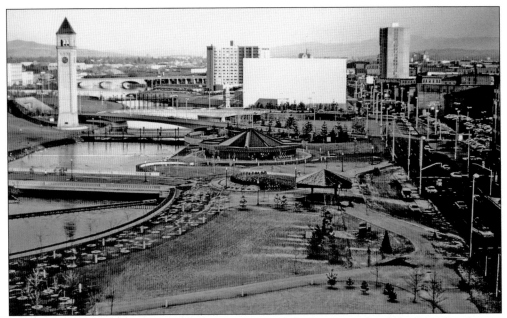

This view to the east shows the clock tower at the far left, the carousel and the State Pavilion in the center, and the Howard Street Bridge in the lower left. At this point, the Howard Street Bridge, entering the Expo area from the downtown core, had become a pedestrian bridge. (Courtesy of the Washington State Archives, Spokane City Planning Collection.)

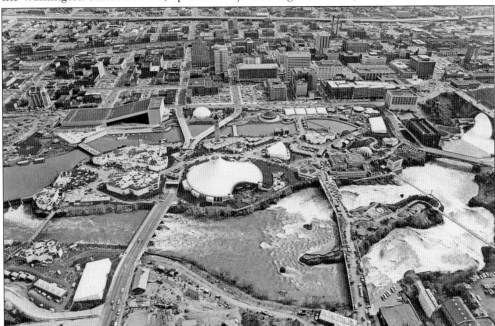

This aerial view was taken during Expo '74. The US Pavilion (center) still stands, minus the canopy, and is a main focal point within Riverfront Park. Today, the pavilion is home to carnival-type rides. The State Pavilion (left) is now the home of the Spokane Opera House. From far left to right are the Washington Street, Howard Street, Post Street, and Monroe Street Bridges. (Courtesy of Spokane Public Library, Northwest Room.)

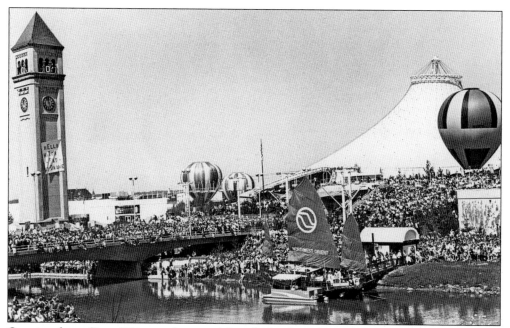

Opening day at Expo '74 is seen here, with hundreds of people on the Washington Street Bridge across the south channel. The fair ran from May through November 1974 and had more than five million visitors. With its environmental theme, it was a departure from the technologically themed fairs of the 1960s. An estimated $150 million was pumped into the local economy. (Courtesy of Spokane Public Library, Northwest Room.)

Pres. Richard Nixon, at podium on the left, officially opened the fair on May 4, 1974. Until the world's fair was held in Knoxville, Tennessee, in 1982, Spokane was the smallest city to ever host the event. (Courtesy of Spokane Public Library, Northwest Room.)

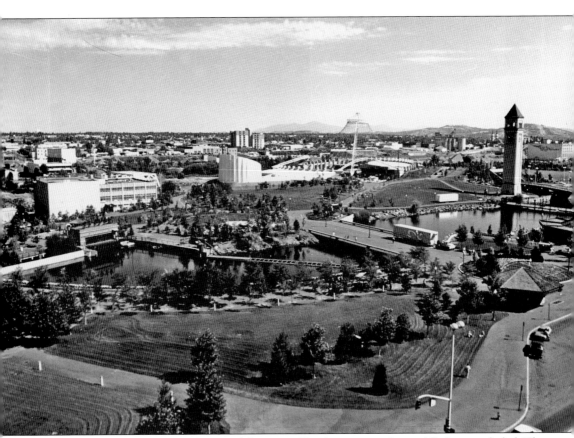

The newly christened Riverfront Park became official as soon as the world's fair concluded. The 100-acre area, which includes Havermale and Canada Islands, now serves as ground zero for year-round events. Events such as Hoop Fest and the Bloomsday Run, as well as the traditional Fourth of July celebration, find Riverfront Park a convenient gathering point. This view shows the solitary Great Northern clock tower along with the remnants of the US Pavilion. The small white structure in the center houses the park's IMAX theater. The carousel (far right) was actually a fixture at Natatorium Park as early as 1909. It was eventually restored and moved to its current location, and is still in use. The Howard Street Bridge's south channel span is in the foreground. (Courtesy of the Washington State Archives, Spokane City Planning Collection.)

BIBLIOGRAPHY

Bruce, Robin. "Historic American Engineering Recordation for the Washington Water Power Company Monroe Street Plant." San Francisco: National Park Service, 1992.

City of Spokane. City Engineer files for the Howard Street Bridge and the Washington Street Bridge, 1888–1907.

———. Spokane City Council Meeting Minutes, Volumes A–M. Cheney, WA: Washington State Archives, Eastern Region, 1888–1927.

Fahey, John. *The Inland Empire: Unfolding Years, 1879–1929.* Seattle: University of Washington Press, 1986.

———. *Shaping Spokane: J.P. Graves and His Times.* Seattle: University of Washington Press, 1994.

Garrett, Patsy M. National Register of Historic Places, Inventory-Nomination Form, Monroe Street Bridge. Spokane, WA: Office of Archaeology and Historic Preservation, 1975.

Soderberg, Lisa. "Historic American Engineering Recordation for the Washington Street Bridge." Olympia, WA: Office of Archaeology and Historic Preservation, 1982.

———. "Historic American Engineering Recordation for the Monroe Street Bridge." Spokane, WA: Washington State Bridge Inventory, 1980.

Spokesman-Review. Spokane, WA: 1907–1917.

Stratton, David H., ed. *Spokane and the Inland Empire: An Interior Northwest Anthology.* Pullman, WA: Washington State University Press, 2005.

Discover Thousands of Local History Books
Featuring Millions of Vintage Images

Arcadia Publishing, the leading local history publisher in the United States, is committed to making history accessible and meaningful through publishing books that celebrate and preserve the heritage of America's people and places.

Find more books like this at
www.arcadiapublishing.com

Search for your hometown history, your old stomping grounds, and even your favorite sports team.

Consistent with our mission to preserve history on a local level, this book was printed in South Carolina on American-made paper and manufactured entirely in the United States. Products carrying the accredited Forest Stewardship Council (FSC) label are printed on 100 percent FSC-certified paper.